AMERICAN PORTRAIT

THE STORY OF US, TOLD BY US

AMERICAN PORTRAIT

THE STORY OF US, TOLD BY US

HarperOne

An Imprint of HarperCollins*Publishers*

HarperCollins books may be purchased for educational, business, or sales promotional use. For information, please email the Special Markets Department at SPsales@harpercollins.com.

Cover Submissions (L to R, Top to Bottom): Joshua B., Maxi G. / Zia N., Cadyn R., Malchus C., Deborah R., Jeanne R., Cowboy / Stephanie S., Anonymous, Lauren W., Chris C., Monique W. / Clara H., Ryan H., Markus H., Libby K., Tracey O., Phillip M., Watie W. / Nick B., & Adam S.

FIRST EDITION

DESIGNED BY RADICALMEDIA

ISBN 978-0-06-314339-5

ISBN 978-0-06-309890-9 (LIBRARY EDITION)

21 22 23 24 25 WOR 10 9 8 7 6 5 4 3 2 1

To everyone who shared, remembered, revealed, imagined, looked, listened and connected. Thank you for creating this *American Portrait*.

CONTENTS

I was raised to believe that the things we have in common, the things that unite us, outnumber the differences that can separate us. This foundational idea is at the very heart of our mission in public television, and it's why we decided to make *American Portrait* the signature initiative of our 50th anniversary celebration.

The year 2020 was extraordinary. The word "unprecedented" was used over and over again—so much so that we became numb to its meaning. There are only so many times you can be presented with something "unprecedented" before you find yourself tuning out, anticipating what's next, or waiting for the other shoe to drop.

A global pandemic. A long-overdue reckoning for systemic racism and injustice. Political upheaval and animosity at a level rarely, if ever, seen. Record unemployment, disconnection from loved ones, a complete upending of how we live, learn, and work.

And, of course, loss. The devastating loss of too many friends, family members, neighbors.

And yet, amid the darkness . . . there was also light.

Fred Rogers often quoted his mother, who told him to "look for the helpers." As she said, "You will always find people who are helping." And that's exactly what we witnessed this year. All around us, people stepped up

to help. They stepped up to heal. They stepped up to fight for what's right. They stepped up to speak their minds. They stepped up to comfort. They reaffirmed what I was raised to believe—that there is more that unites us than divides us.

And *American Portrait* captured it all.

When PBS launched *American Portrait* in January 2020, we had no idea what the year would bring. The project began to take shape in 2017, shortly after the events in Charlottesville, Virginia, where the divisions that were forming in the U.S. seemed to crystallize. As the nation's public broadcaster, we felt the need to address these divisions in some way. The question at the center of our work was "What does it really mean to be an American today?"

But how do you go about answering a question that, in and of itself, can be so polarizing?

We decided that the only way to answer such a profound question was not actually to ask it but to instead let all of you tell your stories (with a little help from some prompts to start the conversation) in the hope that, together, all of those stories would paint a more complete picture. We worked with our local stations across the country to tap into their communities, encouraging people to participate and seeking to discover what issues were important to them and why.

We were off to a great start in January.
And then the whole world changed.

At first, we didn't know how the pandemic would shape the direction of this nationwide initiative. But something incredible happened. *American Portrait*, which was always designed to reflect what was going on in the country at any given moment, did just that. We launched new prompts to encourage people to share their stories. "I NEVER EXPECTED . . ." became an outlet for people to share how the COVID-19 pandemic had upended their lives and how they were coping with it. "NOW IS THE TIME . . ." became a rallying cry for people to speak out against racial injustice.

People from every state and every territory joined in to tell their stories. Some were frustrated, some were sad, some were joyous, some were funny, some were scared—but all of them had one thing in common. They were all open and honest. People opened their lives, told their stories, and shared.

As I write this, nearly 14,000 stories have been shared on the *American Portrait* site. What you hold in your hands is merely a small sample of those stories. This book attempts to capture the various ways that we all experienced 2020—the good, the bad, and everything in between. Maybe your story is in here; maybe it's not. Regardless, I believe that there is a story (and, I hope, more than one) on these pages that will make you think, *That person is like me*—for that is the key to bringing us together.

The things that unite us, and what we have in common, will always outnumber the things that divide us. But there is also something to be learned from our differences. By seeing what is similar and what is different, we come to understand each other better. It helps us recognize that every person has a unique story, and everyone faces their personal challenges in their own way. That recognition generates empathy and enables us to begin to do the thing that is so important to our ability to forge a brighter path forward: listen to each other.

I'd like to share one more thing I was raised to believe. I was raised to believe that, together, we can do extraordinary things. It's the cornerstone of public broadcasting—that together we can educate, enlighten, engage, and, in doing so, raise us all up. Together, the team at PBS and our partners at RadicalMedia created something unique in *American Portrait*: an answer to the question, "What does it really mean to be an American today?"

Flip through these pages and you'll find the answer.

Paula Kerger
President and CEO, PBS

ABOUT

Launched on January 10, 2020, PBS *American Portrait*, a national storytelling project aligned with PBS's 50th anniversary, is the organization's most ambitious multiplatform project in its history. A digital-first initiative produced with RadicalMedia, *American Portrait* began by engaging people across America to share their experiences, hopes, and values by responding to thought-provoking prompts with video, photos, and text. The project evolved to include a digital miniseries, public art installations and murals in neighborhoods across the country, educational materials on media and storytelling from PBS LearningMedia, three broadcast specials in 2020, and a highly anticipated four-part documentary series that aired in January 2021.

Leveraging the local reach of PBS through its member stations, PBS *American Portrait* presents a mosaic of our country's diversity by connecting tens of thousands of people across the country by telling and sharing their own stories. Whether it was joy or sorrow, triumph or hardship, family traditions followed for decades or the everyday chaos of the school run, people offered a glimpse into their lives. Across the country, people read, watched, and listened. People felt heard, sometimes for the very first time. What's your story? The *American Portrait* is not complete without it.

pbs.org/americanportrait
#AmericanPortraitPBS

 PBS

With nearly 350 member stations, the Public Broadcasting Service (PBS) offers people across America the opportunity to explore new ideas and new worlds through television and digital content. Each month, PBS reaches nearly 100 million people through television and nearly 28 million people online, inviting them to experience the worlds of science, history, arts, drama, nature, news, and public affairs.

RadicalMedia

RadicalMedia, a fully integrated global media and communications company, is proud to collaborate with PBS and our partners on this extraordinary, groundbreaking project.

TRAD

"If you don't know where you're from, you'll
have a hard time saying where you're going."

—Wendell Berry

TION

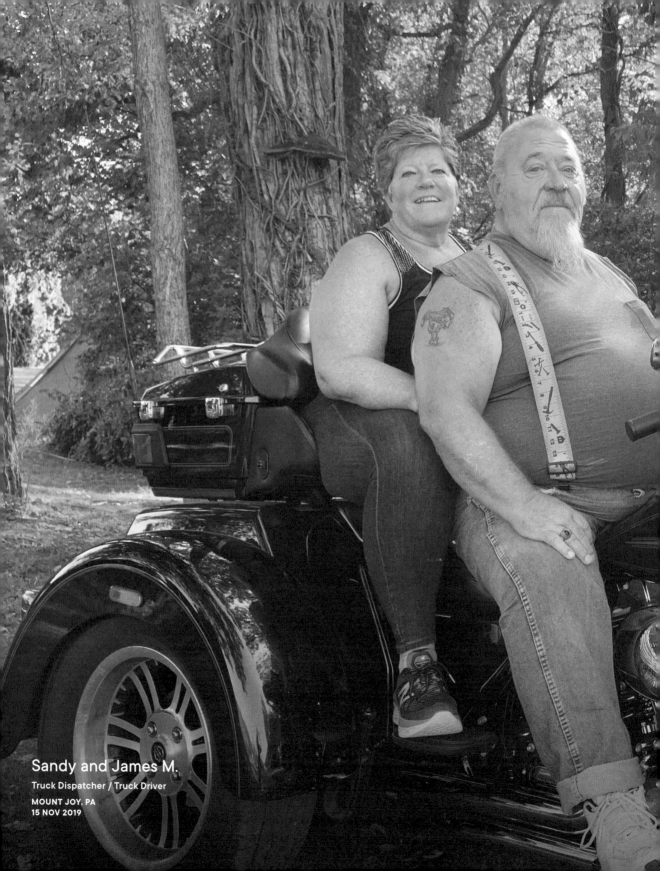

Sandy and James M.
Truck Dispatcher / Truck Driver

MOUNT JOY, PA
15 NOV 2019

"The tradition I carry on is family reunions."

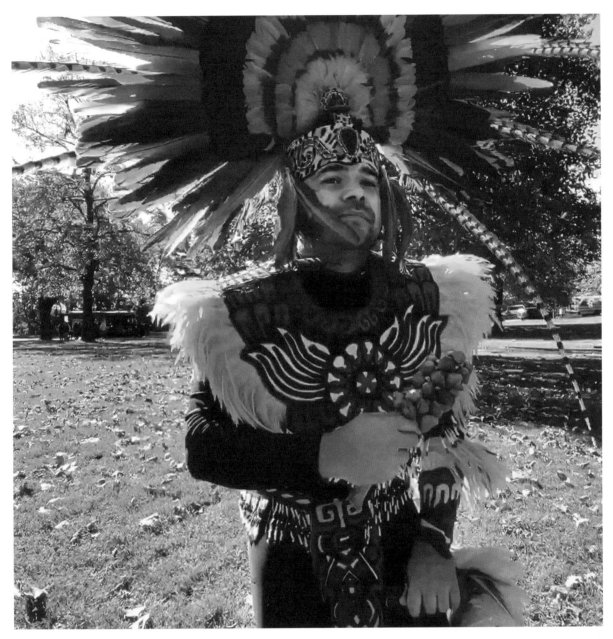

"THE TRADITION I CARRY ON IS traditional dance. My name is Cenoch. That means first cactus. The tradition I carry is that of the Nahwa Mashika people. I carry on the tradition of dancing, history, language, drum, and everything that perhaps you saw earlier in this video. We are here to represent resistance, to carry on the resistance, and the traditions and the culture that has been inherited to us by our ancestors for over 500 years."

Sergio Quivoz C.

Organization Director /
Indigenous Roots

**SAINT PAUL, MN
14 OCT 2019**

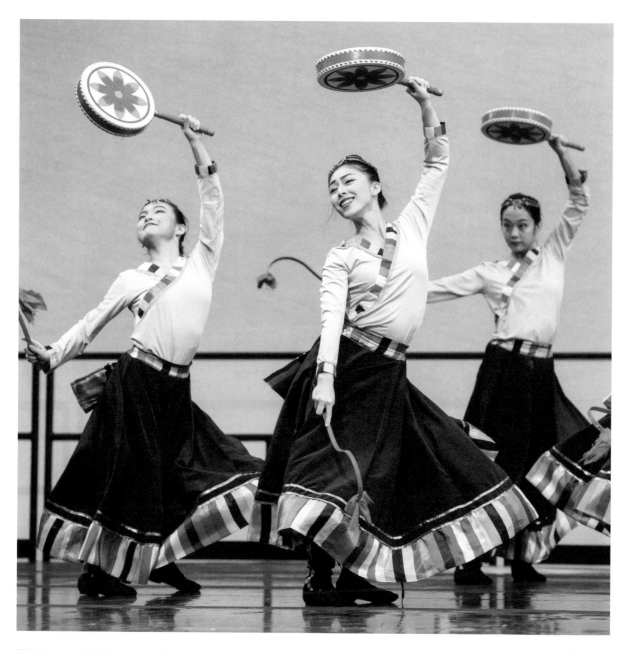

"THE TRADITION I CARRY ON IS Chinese performing and visual arts. As a Chinese American, it is important to me to understand, preserve and celebrate my Chinese heritage. I help preserve traditional Chinese dance, music, kung fu, Chinese calligraphy, painting and paper cutting through my work with New York Chinese Cultural Center. I am proud to be able to do my share in carrying on these traditional art forms."

Ying Y.

Executive Director /
New York Chinese Cultural Center

**NEW YORK, NY
13 JAN 2020**

"Every Sunday, Spring through Fall, my paternal grandparents would go to the cemetery to water the plants in the huge urn on my grandmother's family plot.

This was part of their Sunday drive, which I often joined. We were not alone in this. Most of the large family markers had some sort of adornment on holidays and many had fresh ones throughout the year. My mother placed flowers from her garden on her mother's grave. I remember Memorial Day most fondly; I can still smell the peonies."

Carol Ann C.

Age 63

GREENFIELD, OH
08 FEB 2020

"THE TRADITION I CARRY ON IS my grandmother's. She came to Nogales as a young teacher. All her students spoke only Spanish, so she played the piano and they sang together. When 'wetbacks' came to her door on the small ranch which her husband ran while she taught, she made sure to fix them a meal. She once cared for the child of an immigrant mother who was ill. The last thing that Danna did was try and help a frightened immigrant. Perhaps that's why I did social service work with the first Sanctuary movement. Our beautiful Guatemalan daughter Leticia was an unaccompanied minor and her daughter is now a junior at the U of A. We love them so. I still work with Sonoran kids with special needs at a monthly border clinic. I tell Leticia that her abuela sent her to us. And somewhere I can feel my own grandmother smiling."

Sharon H.

Age 71 / Speech-Language Pathologist

TUCSON, AZ
17 AUG 2020

"THE TRADITION I CARRY ON IS washing my hands in coins on New Year's Day for prosperity."

Cassandra S.
BIRMINGHAM, AL
29 MAR 2020

"THE TRADITION I CARRY ON IS to write or meditate every day—just to take a second to speak what I want into the universe and count my blessings. It's something I've seen my mother and my grandmother do my entire life."

Aakruti S.
Age 29 / Business Data Analyst
AURORA, CO
09 DEC 2019

"THE TRADITION I CARRY ON IS watching 'The Quiet Man' movie with my siblings every St. Patrick's Day to pay tribute to our Irish heritage and family ties."

Mary B.
CHICAGO, IL
10 MAY 2020

"THE TRADITION I CARRY ON IS black beekeeping, an underrepresented ancestral art form."

Cameron R.
Age 20 / Apist /
Black Hives Matter
NEVADA CITY, CA
01 AUG 2020

"The tradition I carry on is a dance style called Waacking, that was born out of the LA disco clubs of the 70's."

Ausben J.
Age 37 / Performer, Director, Videographer, Content Creator, Teacher / IHOW, The Rhythm Of Aus
FORT WORTH, TX
15 SEP 2020

"**THE TRADITION I CARRY ON IS** celebrating the history and revelry of Mardi Gras. As owner of a 102-year-old restaurant in the French Quarter, the tradition was instilled in me at a young age, when my parents purchased the restaurant from Germaine C. Wells, daughter of founder Arnaud Cazenave."

Katy C.
Restaurant Owner /
Arnaud's Restaurant

NEW ORLEANS, LA
11 FEB 2020

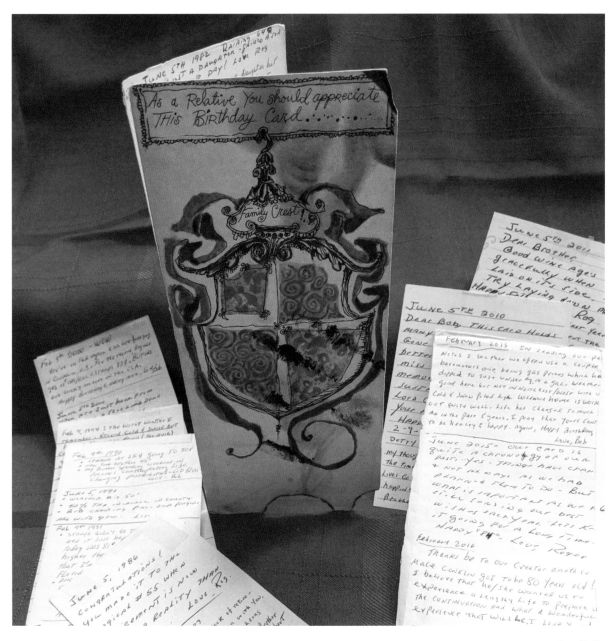

"THE TRADITION I CARRY ON IS . . . As he mailed a birthday card to his younger brother in February 1966 my father did not know he was igniting the flame of a tradition that would continue into the next millennium. It was not until my uncle sent the same card back to my father in June that the tradition truly began. For fifty years the card traveled thousands of miles, delivered by mail or in person twice a year, to keep the brothers connected. Always, there was a handwritten note. Fifty years after the first mailing my father died unexpectedly. He had come back to his hometown to visit from his new home in Florida. In his suitcase was the card. My uncle treasured it before his death in 2020 and the card passed to the next generation. This is the tradition I carry on."

Jodi G.

Age 61 /
Hospice Volunteer

**BINGHAMTON, NY
06 JAN 2021**

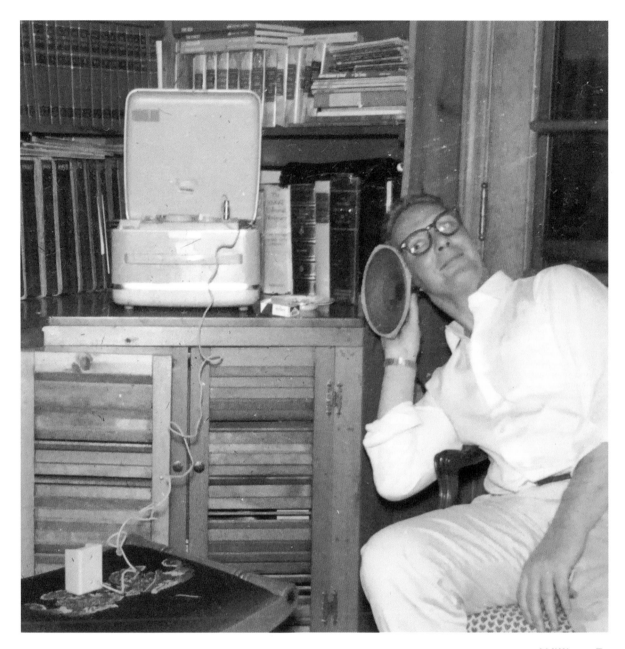

"THE TRADITION I CARRY ON IS . . . My father loved to document life. Here he is in 1962 with his reel to reel tape recorder. He'd use it to record audio letters and send them off to distant relatives. When I was 4 years old he'd sit me in front of the microphone and tell me to talk to my older brother, who was stationed overseas in the Air Force. I thought my brother was inside the recorder. I'd say, 'Hi Dean in there. How are you?' My brother loved getting those tapes. He'd make his own and send them back to us. My father died when I was only 15. But his love for documenting life lives on with me. I grew up to become a successful documentary filmmaker. I no longer have my father or my brother to talk to now. But I still have those old reel to reels. I listen to their voices now and they come alive for me all over again."

William R.
Documentary
Filmmaker

**NEW YORK, NY
22 JAN 2021**

"A Quinceañera in our tradition means maturity, growth and blessing for a woman to become 15. It's the family blessing to a 15 year old wishing her well. At a Quinceañera event you will find a mix of emotions, from laughter to joy to crying . . . From a photographer's point of view, we get to witness most moments other people won't get to see, as we follow the Quinceañera around the whole day, from getting ready to the end of the night."

Daniel S.

Age 26 / Photographer
WIMAUMA, FL
10 MAR 2021

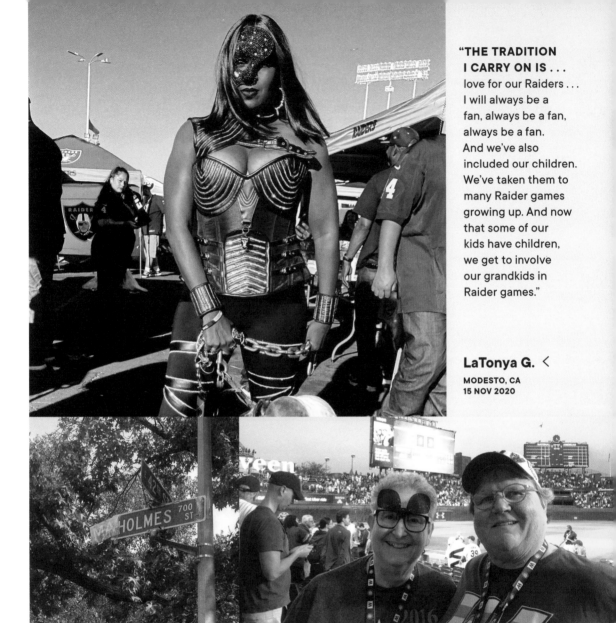

**"THE TRADITION
I CARRY ON IS . . .**
love for our Raiders . . .
I will always be a
fan, always be a fan,
always be a fan.
And we've also
included our children.
We've taken them to
many Raider games
growing up. And now
that some of our
kids have children,
we get to involve
our grandkids in
Raider games."

LaTonya G. ‹

**MODESTO, CA
15 NOV 2020**

**"WHEN I STEP OUTSIDE
MY DOOR** I see how
much this town loves
Patrick Mahomes."

Anonymous ∧

**KANSAS CITY, MO
23 SEP 2020**

"THE TRADITION I CARRY ON IS . . . Love of baseball has
percolated through our family. The story even goes that my
grandpa's sister loved baseball so much—and as a woman in
the 1920s, wasn't able to play—she dressed as a boy so she
could go out and play baseball with the boys. Here we are
today . . . Wrigley Field, mecca for all of us."

Gail M. ∧

**CHICAGO, IL
31 OCT 2020**

"**THE TRADITION I CARRY ON IS** the game of lacrosse . . . This game is considered a medicine game for our people . . . The traditional name for it is Deyhontsigwa'ehs, which means 'they bump hips' . . . Those big-time sports, I don't think that they have that cultural aspect to those games that lacrosse does. I think that's something that sets us apart."

Brandon B. ‹

SYRACUSE, NY
28 JAN 2021

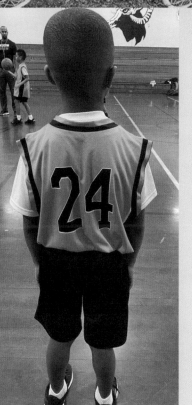

"**THE TRADITION I CARRY ON IS** raising my sons to be great basketball players, following in the footsteps of their dad. In this photo, my 7-year-old son proudly wears his #24 basketball jersey before a Sunday game, a week after the tragic passing of basketball legend Kobe Bryant."

Maria G. ‹

BOWIE, MD
03 FEB 2020

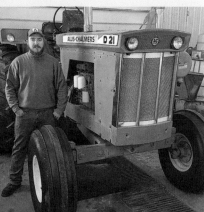

"**THE TRADITION I CARRY ON IS** tractor pulling . . . a form of motor sports that consists of drivers and their tractors competing against each other to see who can pull the most weight . . ."

Mark S. ∧

SHIPPENSBURG, PA
21 NOV 2020

"MY SATURDAY NIGHT LOOKS LIKE football . . . It's my favorite sport and what gives me that peace of mind." CRAIG W. — JOHNSTON, IA

"THE TRADITION I CARRY ON IS fishing. My parents never had their traditions but fishing is something that I fell in love with. And now, as a grandpa, I pass it on to my kids and even their kids. We kinda all go out to the lake side and fish together and for us, that's how we all bond and pass the time."

John B. ‹

JOHNSTON, IA
03 DEC 2019

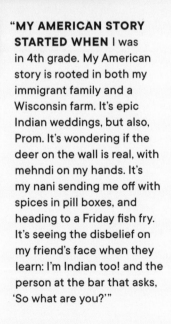

"MY AMERICAN STORY STARTED WHEN I was in 4th grade. My American story is rooted in both my immigrant family and a Wisconsin farm. It's epic Indian weddings, but also, Prom. It's wondering if the deer on the wall is real, with mehndi on my hands. It's my nani sending me off with spices in pill boxes, and heading to a Friday fish fry. It's seeing the disbelief on my friend's face when they learn: I'm Indian too! and the person at the bar that asks, 'So what are you?'"

Pierce B. ‹

SAN FRANCISCO, CA
15 JAN 2020

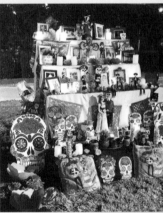

"THE TRADITION I CARRY ON IS celebrating Día de los Muertos every year to celebrate life and loved ones!"

Anonymous ⌃

LAS VEGAS, NV
10 JAN 2020

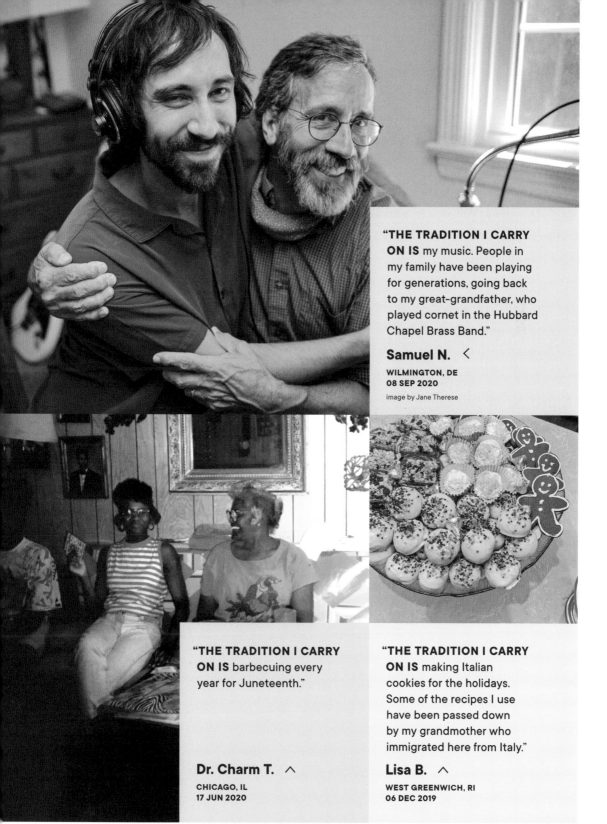

"THE TRADITION I CARRY ON IS my music. People in my family have been playing for generations, going back to my great-grandfather, who played cornet in the Hubbard Chapel Brass Band."

Samuel N. ‹

WILMINGTON, DE
08 SEP 2020

image by Jane Therese

"THE TRADITION I CARRY ON IS barbecuing every year for Juneteenth."

Dr. Charm T. ∧

CHICAGO, IL
17 JUN 2020

"THE TRADITION I CARRY ON IS making Italian cookies for the holidays. Some of the recipes I use have been passed down by my grandmother who immigrated here from Italy."

Lisa B. ∧

WEST GREENWICH, RI
06 DEC 2019

"The tradition I carry on is being the history keeper in my family. I write down their stories and save their belongings to keep their spirits alive . . .

I have the family Bibles, the old wedding albums, and I have more china than I could ever possibly use . . . So I know which grandmother this belonged to and why this particular bowl was meaningful to them. For me, these objects all have these stories that go with them . . . The people are gone, but their things are still here. And I guess I just believe somehow that these things carry their spirits. And for that reason, I cannot get rid of them."

Mandy S.

Writer, EMT

PROVIDENCE, RI
31 MAR 2020

"THE TRADITION I CARRY ON IS the art of weaving. It is art that requires patience, persistence, and practice, but is one I plan to share with kids I may have in the future and continue to share with my community. Weaving is a way we are able to connect with our elders and ancestors in order to keep our culture close to our hearts."

Shannon S.

Miss Northern Marianas 2019 / Stellar Marianas

SAIPAN, MP
23 OCT 2020

"THE TRADITION I CARRY ON IS playing the violin. My cousins, second cousins, and myself all played the violin growing up, and my Aunt Mary, who has a small collection of violins, would lend us bows and violins. When I decided to continue studying violin in college, my aunt handed down to me one of her cherished violins that I still play on today."

Haley E.

Age 23 / Full-Time Student and Actor

GREEN BAY, WI
12 DEC 2019

"THE TRADITION I CARRY ON IS sharing my Polynesian heritage. I am Samoan. You may see it in the color of my skin or the thickness of my hair. You may learn it through the grace of my hands or the intricacy of my Tuila. I am Maori. You may hear it in the strength of my karaga or the melody of my waiata. You may feel it in the tremble of my whiti or the whirl of my poi. I am Hawaiian. You may smell it in the fragrance of my blossoms or the saltiness of my ocean. You may learn it from the stories of my kupuna or the sweetness of our aloha. I am American. My ancestors were masterful navigators who charted the stars from Hawaiki to Samoa, Aotearoa, and Hawaii. I am all of these. Strong, soft, proud, humble, Polynesian, American and I share the heritage of my aiga, whanau and ohana with love."

Whitney S.

FAIRFIELD, CA
27 FEB 2020

"THE TRADITION I CARRY ON IS elbow-grease of my Grandmama Evada. She used to drink coffee out of a jade cup in the morning, Mountain Dew in the afternoon, and the sweetest tea you ever tasted for supper. My grandmama Evada taught me how to fillet a fish and shell peas; elbow grease was a regular part of her vernacular. The serenity prayer was glued to the dashboard of her peach Malibu Classic and I read it while her cigarette smoke swirled around my head."

Amanda M.

Age 48 / Special Educator

WAITSFIELD, VT
20 MAR 2020

FAM

ILY

"The love of the family, the love of one person can heal. It heals the scars left by a larger society. A massive powerful society."

—Maya Angelou

"I have a biological family and they're great, they're fantastic. But I also have a family that I got to choose."

Dedrick P.
Social Worker
OKLAHOMA CITY, OK
15 JUN 2020
Image by McKinleigh Lair

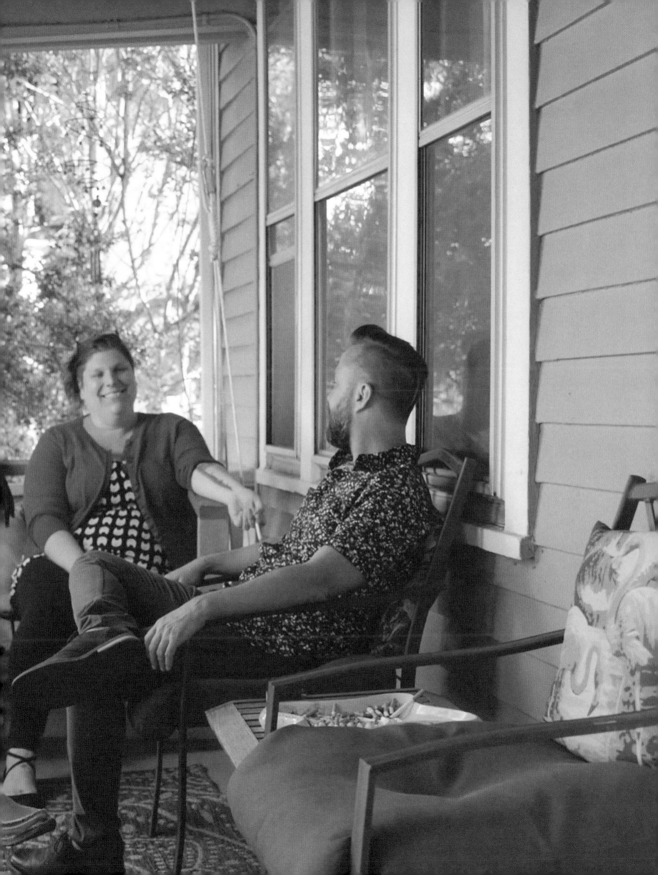

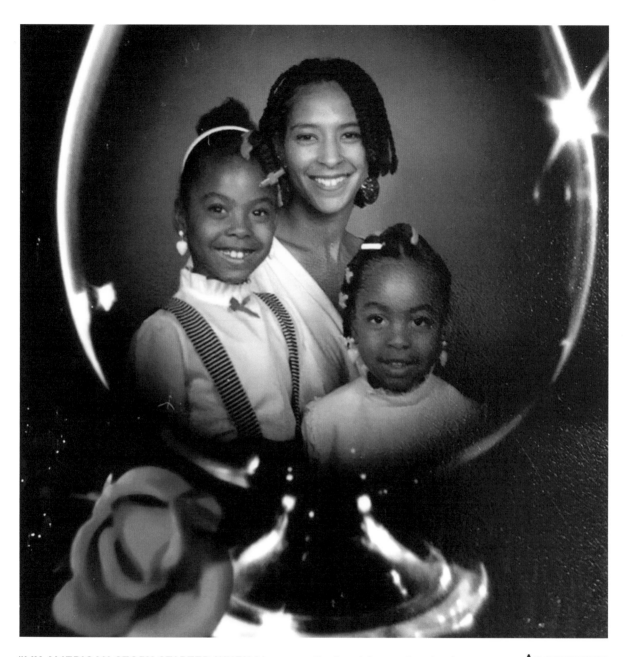

"**MY AMERICAN STORY STARTED WHEN** I began motherhood. I never imagined being a single mom would produce two beautiful, brilliant, educated, hardworking young ladies. The dichotomy of parenting was a reflection of planning, impromptu, fearful, fearless, laughter, tears, forgiveness, forgetfulness, yays, nays, resentment, redemption but mostly God, Prayer, Hope, Faith and Love. Children are a blessing not a burden. 'While we try to teach our children about life, our children teach us what life is all about.'"

Anonymous
NEWBURY PARK, CA
16 FEB 2020

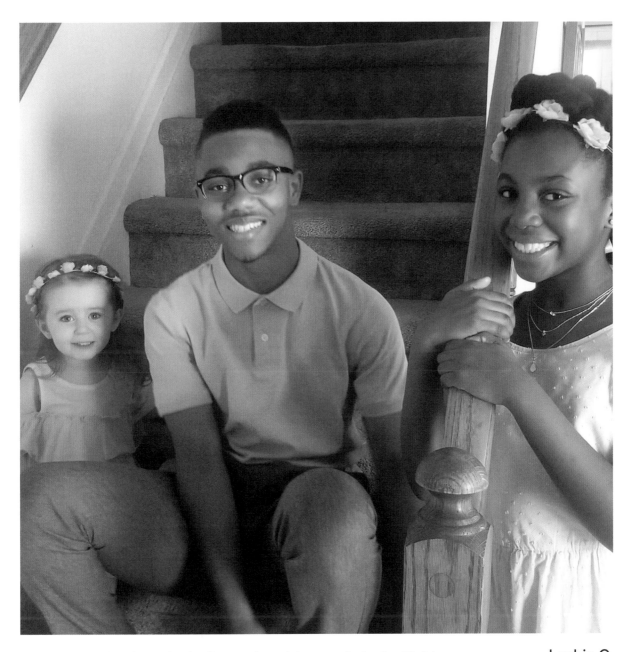

"FAMILY LOOKS LIKE . . . Our family grew through foster and adoption. Their love for each other is unconditional. We admit, our family does not look 'traditional,' but you have to admit we exude love and joy! Our forever family (adoption) day is one of the most memorable days for our community."

Leshia C.
FREDERICK, MD
02 JUL 2020

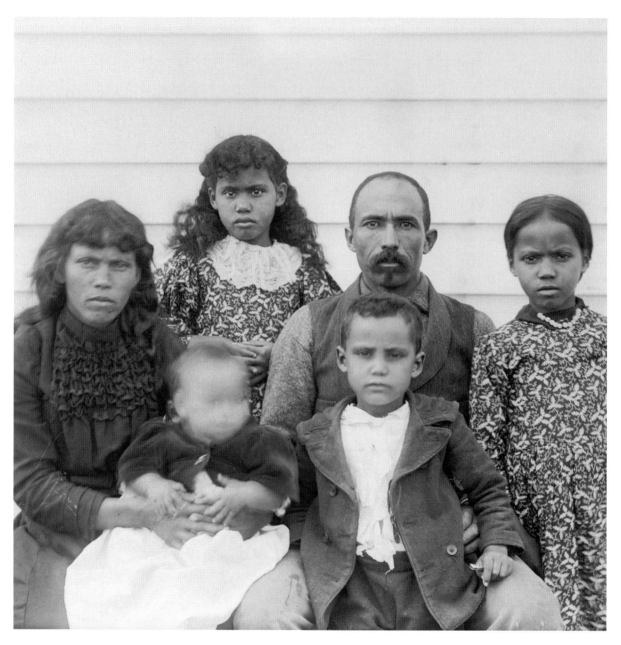

"MY AMERICAN STORY STARTED WHEN my mother's family—the Collins Family—were residents of the Pamunkey Indian Reservation in Virginia. Pictured here: my great-grandfather, John Temple Collins, and his wife, Harriet Bradby, and their children on the Pamunkey Indian Reservation in October of 1899."

Anonymous
WARRINGTON, PA
16 AUG 2020

"**FAMILY LOOKS LIKE** those who raise you. My father was a WW2 vet who believed that you needed to do your best at whatever endeavour you engaged in. He also believed in standing by your ethics. Because so many people commented about how much we looked alike, I tried to be like dad."

Lisa G.

Age 69 / Retired U.S. Marshals Service /
World Wildlife Fund,
The Innocence Project,
Houston Museum of Fine Arts

SPRING, TX
18 JUN 2020

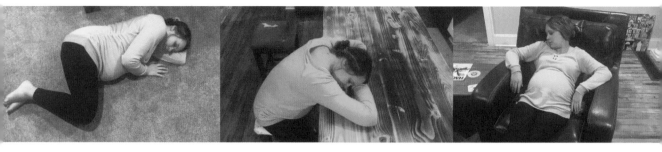

"MOST DAYS I FEEL tired. Working full time while being 8 months pregnant is exhausting."
DANAE B. — KANSAS CITY, KS

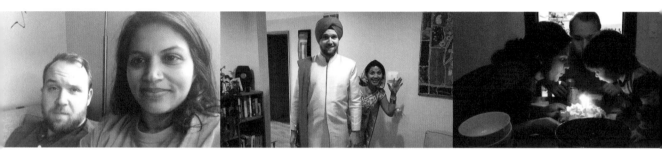

"I NEVER EXPECTED to be having our second baby amidst a pandemic. Having a child without any family around to support you . . . is going to make this a very lonely experience." **RUBY D. — SEATTLE, WA**

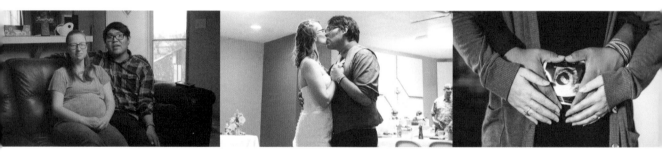

"I NEVER EXPECTED that our first pregnancy would be in quarantine." **WADE A. — WINDOW ROCK, AZ**

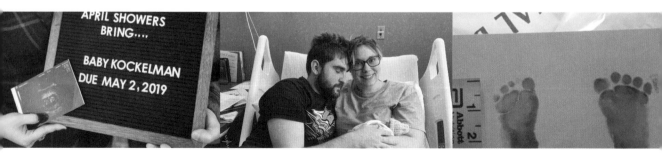

"MY AMERICAN DREAM . . . is to have a family . . . We became pregnant a year into our marriage. Due to an autoimmune disorder I didn't know I had, our son, Rowan, came early at 25 weeks . . . After a tough fight two days later, he went to heaven." **SHAELI K. — CAMERON, WI**

Images by Satinder Kaur

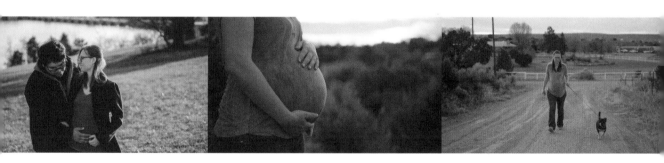

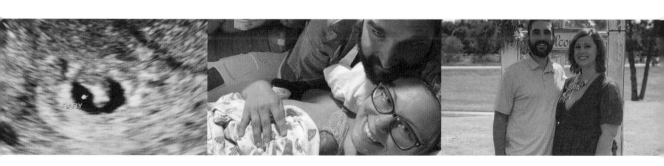

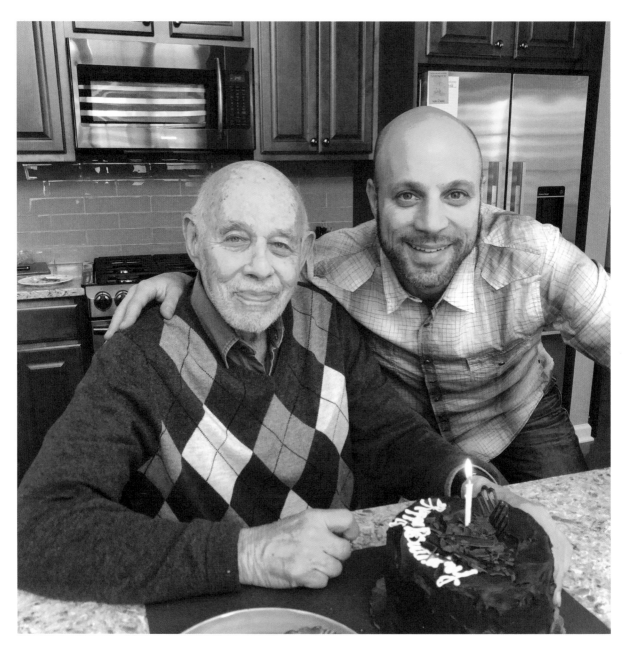

"WHAT KEEPS ME UP AT NIGHT IS . . . the fear of losing my father. I lost my mother suddenly in 2016 and as a result I found something out about myself. I don't handle death well. My father has been my best friend, and my guiding light throughout my life . . . At 90 years old now, he is the strongest man I know. Even 90 has its limits though. It breaks my heart to see him struggling to do some of the most basic things . . . I can see right through my father's eyes and tell how he feels . . . I don't know what I would do without him in my life. This is what keeps me up at night. As I write this, tears fall down my face, because I am truly terrified to lose my rock."

David K.

Age 47 /
Doctor of Chiropractic /
Business Owner

**NEW YORK, NY
19 DEC 2019**

"**FAMILY LOOKS LIKE** my mother. Through divorce, different homes, and all manner of disappointments, she has remained the steadiest person in my life. No matter what decisions I make or where I go, I know there is always a place for me wherever she is."

Jessie E.

Actor

CARMEL, IN
13 JAN 2021

"FAMILY LOOKS LIKE spending time with the new generation and passing down these traditions. Now that I am older, I have lost most of my family, but I am fortunate enough to have two children and three grandchildren to spend the holidays with. Because of my children, I have been able to see the world, witness my grandchildren find themselves and grow, and experience so many wonders. My friends are also my family, as I still go to book club and call the friends that I have made on my mystery trips throughout the years. To this day, I still tell stories of my grandparents to my grandchildren, reminiscing on my wonderful childhood memories, and forever wish that my grandchildren could have met my parents. Family to me is unity, strength, love, and security, and I wouldn't be the woman I am today without it."

Beverly H.

Age 81

UNIVERSAL CITY, TX
02 DEC 2020

PBS AMERICAN PORTRAIT : FAMILY

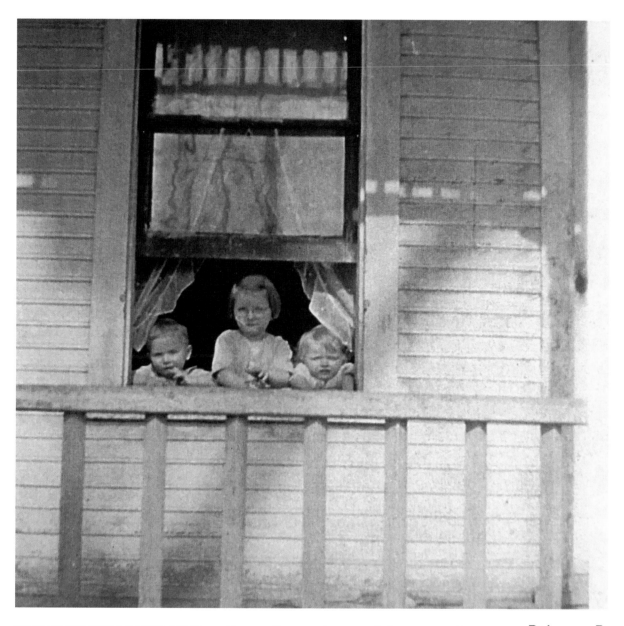

"THE TRADITION I CARRY ON IS . . . I lost my first grandparent a little over a week ago, and find myself searching for his childhood stories I forgot to ask about. Asking many questions that may never have answers, letting myself wonder as a way to stay connected. Finding those relatives that carry stories that I haven't heard. Wondering: how do these experiences get passed on to us, even when we don't realize it? How much of that little boy in the window lives on in me?"

Rebecca B.
ADEL, IA
27 MAY 2020

"Family looks like me (71), my two adopted daughters (20 and 25), and my daughter relinquished at birth (50) and unavailable for contact until her early 30's.

It's a long story and ultimately, one that makes sense for everyone. I grew up in Nebraska, my daughters were born in China, and my biological daughter is a successful professional who now resides in California. She is happily married, with 3 children. So I'm publicly a mom and unofficially a grandmother who enjoys seeing updates and photos once a year."

Anonymous

HIGHTSTOWN, NJ
08 AUG 2020

"NOW IS THE TIME . . . I found out that I have an adult son six months ago, and we've bonded like we've lost no time . . . I looked at him, I said, I thought I was looking at myself in the mirror. He looked just like me and I told him, we didn't have to take a blood test, you're my son . . . So, I mean, it's a story to tell. I love him to death. He has two girls, he has a wife and they are doing good for themselves. I never knew that I had two granddaughters and they is my heart."

Terry D. S.

Age 51

SCOTT, AR
01 OCT 2020

"FAMILY LOOKS LIKE . . .
It's been really hard these past few months not having my father around . . . It seems like each day is longer because I don't have the person who has always given me his love . . . It shouldn't be a crime to be an immigrant in the United States . . ."

Jocy P.
Age 18 / Student
LOUISVILLE, KY
27 AUG 2020

"I NEVER EXPECTED
to birth & bury our daughter before ever celebrating her first birthday."

Deborah M.
Age 50 /
Ch8sing Waterfalls / GirlTrek
LAWRENCEVILLE, GA
16 OCT 2020

"MY AMERICAN STORY STARTED WHEN . . .
I am currently separated from my own immediate family due to incarceration. Nonetheless, my family was built on a solid foundation of love and understanding. Because of this, I have an unbelievable support system."

Charles D.
MADISON, WI
18 JUN 2020

"What keeps me up at night is giving up my first born daughter for adoption.

It was a closed one and I believe she is 21 now. I feel like I purposely sabotaged many meaningful relationships after it occurred. My life is definitely what I expected it to be at 37. I am a postal worker but before that a paralegal and before that a pharmacy technician. I am not okay mentally but still provide for my family members who deserve to be loved."

Yanique F.
Age 37 / Post Office / USPS
CHULA VISTA, CA
29 NOV 2020

PBS AMERICAN PORTRAIT : FAMILY

"**I NEVER EXPECTED** to be so desperate for prison visits! Every incarcerated person, like my partner, is somebody's child, brother, husband, father, mother. They are loved, they never stop being your family. They have made mistakes, done bad things in their past. But that doesn't make them 'throw-away' people. Their lives have meaning and value. It's amazing, all the families going to great lengths to visit loved ones in prison. Grandparents in wheelchairs, mothers with babies, children who joyfully run into their fathers' arms. We drive for hours, wait on hard benches, drag kids through the metal detector. We crowd around tables sharing vending machine meals, playing games, reading, talking, doing all we can to squeeze out every bit of family normalcy we can."

Anna W.
Age 42 / Dental Hygienist
MADISON, WI
06 AUG 2020

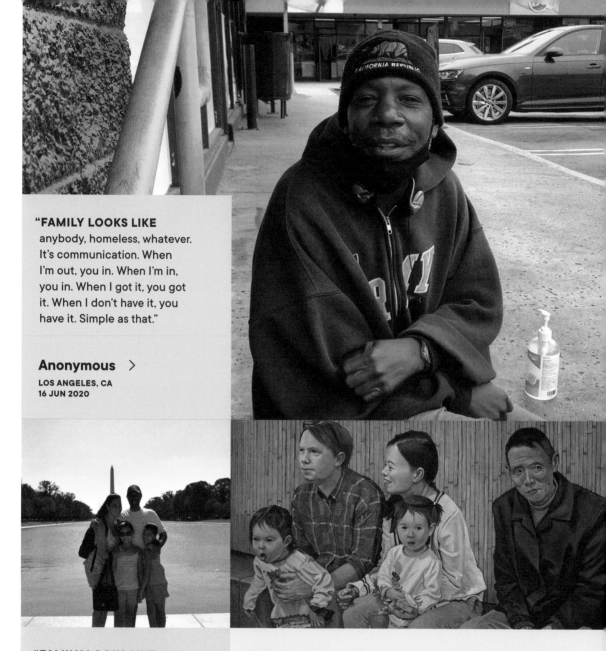

"FAMILY LOOKS LIKE
anybody, homeless, whatever.
It's communication. When
I'm out, you in. When I'm in,
you in. When I got it, you got
it. When I don't have it, you
have it. Simple as that."

Anonymous >

LOS ANGELES, CA
16 JUN 2020

"FAMILY LOOKS LIKE the
melting pot which is the
foundation of America. My wife
and I would have never met in
grade school in Freeport, NY, if my
parents did not immigrate from
India and her father from Jamaica."

Sourav C. ∧

EAST MEADOW, NY
03 JUL 2020

"FAMILY LOOKS LIKE a fairly typical middle class, southern,
small town family . . . with beautiful Chinese/American
granddaughters. I have been painting a portrait of my family
for the last four years, now over 200 paintings and drawings
that cover 5 generations. I have enjoyed a wonderful life that
I have celebrated with my art and I would love to share."

William S. ∧

AUSTIN, TX
22 SEP 2020

"Family looks like paradise and terror all at the same time. A family isn't one that looks or acts perfect, it's actually the complete opposite. A family is a bunch of different people with a bunch of differences coming together and being one."

Emelia M.
SPRINGFIELD, OH
05 JAN 2021

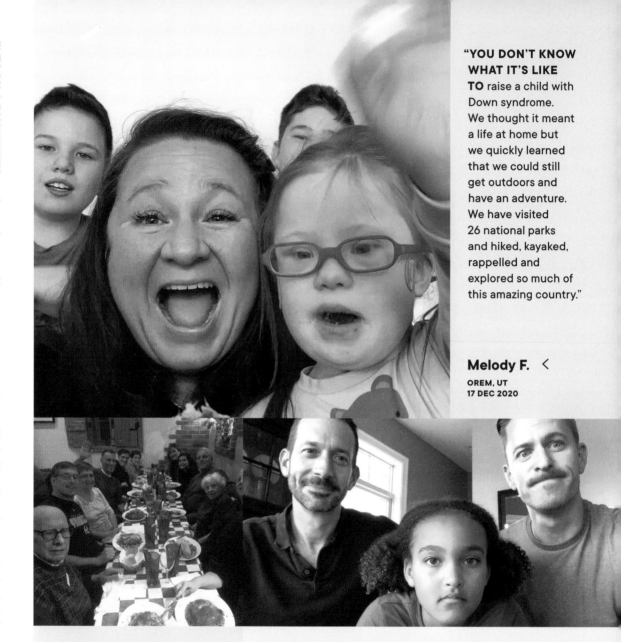

"YOU DON'T KNOW
WHAT IT'S LIKE
TO raise a child with
Down syndrome.
We thought it meant
a life at home but
we quickly learned
that we could still
get outdoors and
have an adventure.
We have visited
26 national parks
and hiked, kayaked,
rappelled and
explored so much of
this amazing country."

Melody F. <
OREM, UT
17 DEC 2020

"FAMILY LOOKS LIKE . . .
I cherish all of my Families.
I am who I am because of them."

Francis V. ∧
NORWALK, CT
10 JUN 2020

"I NEVER EXPECTED that I'd get to be a dad. Part of coming
to terms with being gay when I was a teenager was realizing
that fatherhood was not in the cards for me. This was the
late eighties, early nineties. And the idea of two guys getting
married and having a kid was not on very many people's
radar and certainly not on my radar. And lucky for us,
the world changed."

Michael A. ∧
NAPLES, FL
12 JUN 2020

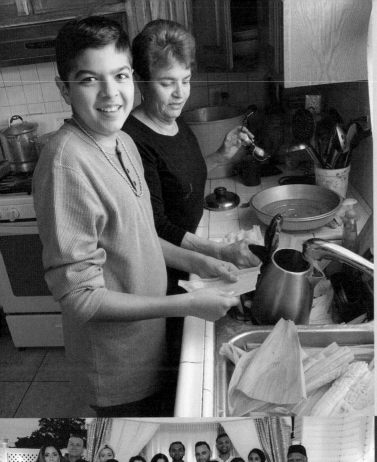

"THE TRADITION I CARRY ON IS making tamales every year with my grandma and family . . . My grandmother is the one in charge. My uncle has to cut the big block of cheese into small pieces. My sister and I always wash all the tamale husks. My mom helps my grandma fill the tamales with either red pork meat or green chile and cheese. The last step is wrapping the tamales in wax paper and that is usually my dad's job . . . Once the tamales are ready my grandpa always likes to taste the first batch. I enjoy being part of this tradition with my family."

Jeric O. ‹

WHITTIER, CA
10 MAR 2020

"FAMILY LOOKS LIKE . . . My parents immigrated to the United States from Colombia. Since then, we've added members to our family from Canada, Costa Rica, Cuba, Mexico, Guyana, Puerto Rico, and Trinidad & Tobago. I am very proud of my American Family."

William G. ᴧ

EAST ELMHURST, NY
09 JUN 2020

"I WAS RAISED TO BELIEVE that a couple's most lasting legacy was their children."

Anonymous ᴧ

SUNAPEE, NH
20 JUN 2020

"MY GREATEST CHALLENGE IS continually putting myself & my recovery first so I can be my best self for my children." BRITTANY S. — OCEANSIDE, CA

"I NEVER EXPECTED to be a single mom with two children & two baby daddies . . ." AMBER B. — PORTLAND, OR

"THE TRADITION I CARRY ON IS adventure! My parents both taught me to take every adventure I can. Now I am passing this tradition on to my two daughters by showing them that their mom faces every fear head on!"

"THE TRADITION I CARRY ON IS . . . We are gonna raise her with the words of Jesus, because Jesus doesn't condemn our family or families like ours . . ."

Brandiilyne M. ∧
HATTIESBURG, MS
16 DEC 2020

Libby K. >
PRAIRIE VILLAGE, KS
10 DEC 2019

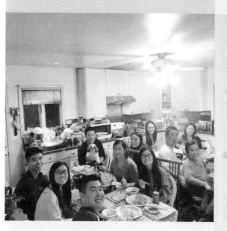

"FAMILY LOOKS LIKE sharing food together no matter if you're happy, sad or angry with each other because we feel blessed to be able to have our family all together here in the U.S."

Anonymous ∧
ROCKVILLE, MD
10 JUN 2020

"NOW IS THE TIME for spending time with family. I moved home to Eastern Washington from Los Angeles when COVID-19 hit the states. I lived with my parents and grandma. I witnessed the love my mom provides for Grandma who has dementia. She performs the ritual of rolling her hair in rollers. Even if she is just spending the day inside reading her paper."

Stephanie S. ∧
WEST RICHLAND, WA
09 OCT 2020

"MY PARENT(S) WANTED ME TO grow up to be a capable, independent, autonomous adult. I always felt that my Dad trusted me a little too much, gave me too much freedom. But he let me make my own mistakes, which are often the most valuable lessons of all."

AJ C. ∧

DENVER, CO
12 DEC 2020

"WHEN THIS IS OVER
I will get on a plane from Virginia to London and hug my identical twin . . . We are so grateful for FaceTime and internet and wacky humor."

Terri R. ∧

ARLINGTON, VA
25 MAY 2020

"FAMILY LOOKS LIKE
two generations of Black resilience, excellence, and love to me."

Shason B. ＞

SAN MATEO, CA
04 DEC 2020

"MY GREATEST CHALLENGE IS living life without my mom, who was & always will be my very best friend. Life's too short, enjoy & appreciate the ones you love."

Anonymous ∧

WEEHAWKEN, NJ
07 JAN 2021

"I ran away and entered the foster care system. I was brought into a home with no clue who these people were . . . Those strangers taught me self-love, strength, and, most importantly, independence. They taught me what it meant to be loved . . . Those strangers in my eyes were my forever family and my heart."

Mayda B.

Age 20 / Foster Care Advocate /
Companion Champions-President

DOVER, DE
14 AUG 2020

"I NEVER EXPECTED to be able to spend so much time with my adult son! He drove cross-country from Seattle with his black lab to quarantine with my yellow lab and me in Key West. We drink Cuban espresso and talk about the people we love. We take the pups for walks and swim in the pool next to a tree that's bursting with mangoes. He works on his start-up while I read, organize, and bake. He makes me literally laugh out loud every day. I thought I'd see him once a year for the rest of my life, so these languorous days in lockdown have been the happiest in my life."

Kim R.

KEY WEST, FL
06 MAY 2020

"MY AMERICAN STORY STARTED WHEN I walked into a routine doctor's appointment with my mother and walked out a caregiver to a dementia patient."

S. Y.

CHICAGO, IL
16 MAR 2020

"FAMILY LOOKS LIKE love in all forms; people who love one another from diverse backgrounds and cultures, able bodied and disabled, gay, queer, straight, average size and short statured."

Meg W.

Age 61 / Educator and Tutor

PORTLAND, OR
24 JUN 2020

"I NEVER EXPECTED to have my son after I was deemed infertile. My quality and quantity of eggs was near-menopausal at the age of 32, so we jumped straight into IVF. The first round we only got 5 eggs and they all died. The second round we got the same and 3 actually survived and are girl embryos! We put them in storage and continued egg retrievals since this would likely be my last chance to get healthy eggs. The next two cycles completely failed. We had to stop treatment in the middle my estrogen was so low . . . I didn't even have 4 viable follicles. I felt broken. The next month, I got pregnant naturally with Matthew!"

Laura K.

Age 34 / Housewife

SEATTLE, WA
18 JUN 2020

"THE TRADITION I CARRY ON IS what it means to be an ada (the eldest daughter) in a country that doesn't understand what such a title means. How to balance duty and honor with self. Realizing that the self is stitched together by the many that I love . . . I'm the ada of my family and that has shaped me into the person I was, I am, and I will be."

Anonymous

DAVIS, CA
13 NOV 2020

FAI

"Some things have to be believed to be seen."

—Madeleine L'Engle

"My teenage years I got very depressed: I wasn't eating, I was hurting myself. I decided to come back here to Missoula where I was born.
And so while I was here, I ended up meeting my now husband, and he is a Muslim convert as well. And one day he showed me how to pray. I just had never felt the level of purity and comfort in that 10 minutes . . . the stomach pains I was feeling for years just like instantly stopped. It's been so rewarding and I've found a lot of peace from it."

Lake D.

Age 21 / Artist
MISSOULA, MT
19 NOV 2019

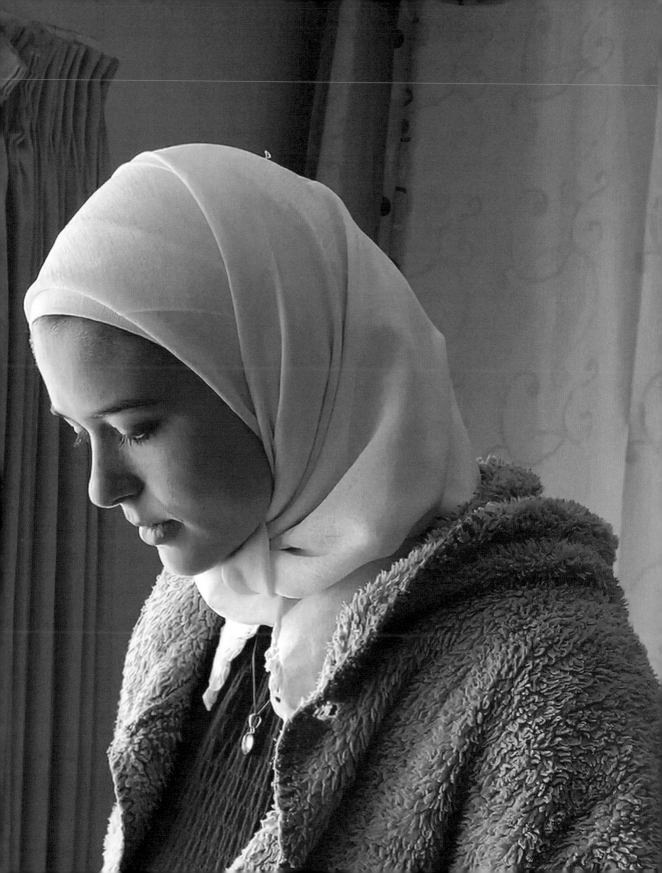

"I WAS RAISED TO BELIEVE that a 3 year old had agency. My parents were highly educated, liberal, sophisticated nincompoops. When my hamster died I put it near the radiator but it remained kaput. What happens when you die? Is there a Heaven? Or just . . . nothing? They lamely explained, 'Well the Buddhists believe this, and the Christians believe that, and we are Jews but not really. Us typical cartoon beatnik radical lefties can't believe in God. It's uncool. But as Jews we feel guilty not giving you a faith.' So I invented my own. I'm a devout Hamster. I needed to believe in a benign power protecting me from idiocy, and have nearly succeeded."

Laurie R.

Age 64 / Artist, Author,
Bumblebee Pirate Clown.
Occasional Swede. / Rosenworld

**NEW YORK, NY
03 MAY 2020**

PBS AMERICAN PORTRAIT : FAITH

"I WAS RAISED TO BELIEVE that ordinary people can do extraordinary things. Growing up, my mom would pull me aside and read Bible stories to me. She would always cast me as one of the characters in the Bible story. She would cast me as Moses as he led the Children of Israel across the Red Sea, this extraordinary thing. I would always wonder how I could do something like that? And she would explain to me, ordinary people can do extraordinary things. Now as a pastor the message I want to share with the world is that same message my mom shared with me."

Garrison H.

Age 29 / Pastor at Community Praise Center — Seventh-day Adventist Church

ALEXANDRIA, VA
14 MAR 2020

Image by Mark Comberiate

"I NEVER EXPECTED . . . The week of your funeral, I drove our car to run some errands for the family. I found this small rosary in your car. You got it when you were in the Holy Land. I'm not religious, but it brings me comfort. It was important to you and you were so proud of this trip. I miss you so much. Sometimes I still talk to you. I wish you were here."

Dana L.
Age 31
WASHINGTON, DC
12 JAN 2021

"I wasn't raised to believe in God. I was raised to believe in people: the goodness of people."

Lauren L.
NEW YORK, NY
26 MAY 2020

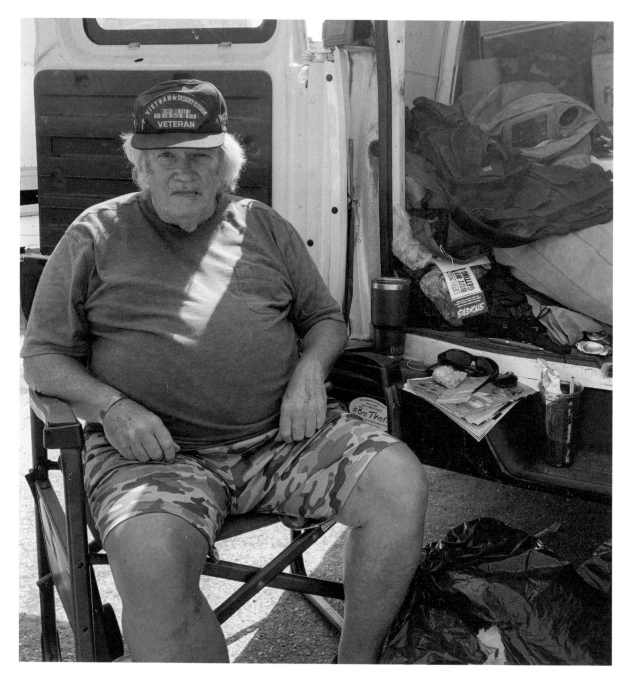

"**I WAS RAISED TO BELIEVE** in God and Country which I'm proud of both."

Dale R.

Age 69 / Retired Military

WILLOW STREET, PA
22 OCT 2019

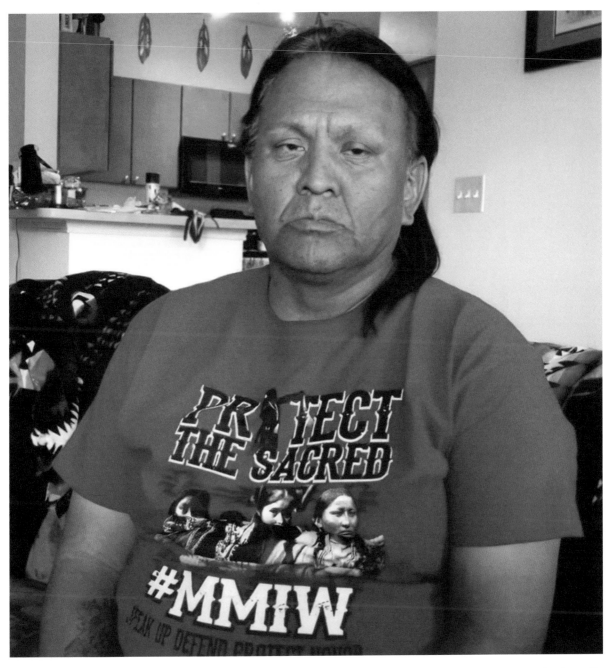

"I WAS RAISED TO BELIEVE in heritage and responsibility to the earth."

Arthur R.

Age 45 / Lakota, Navajo

ROSSTON, TX
10 JAN 2020

"I was raised to believe in Jesus. With all of the control and manipulation going on in church, I'm not so sure now. I do believe in God."

Anonymous
CASPER, WY
21 FEB 2020

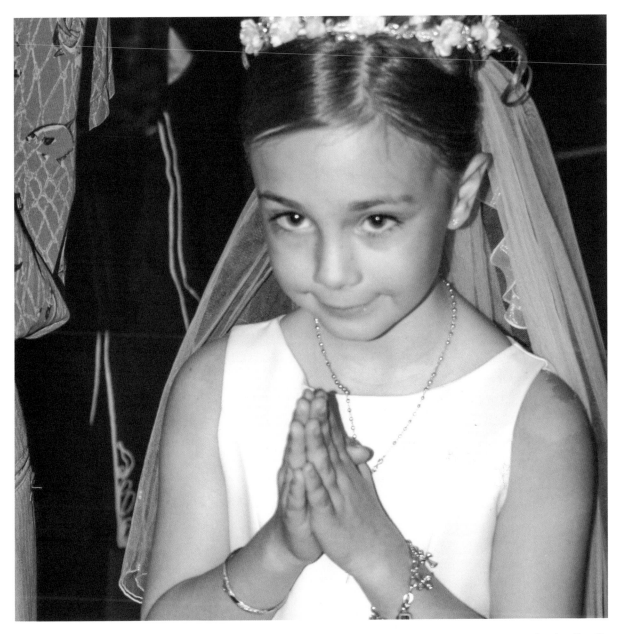

"**I WAS RAISED TO BELIEVE** in the strength of my faith. I was raised to believe in prayer and trust. I was raised to believe in God. My parents, from the day I was born, have instilled in me the importance of having faith, no matter what it be. I identify as a Roman Catholic Christian, but my beliefs go beyond that. I was raised to treat everyone equally, to treat everyone as I would want them to treat me. I was raised to believe in love. My family plays a huge role in my life, and always has. I was enrolled in Catholic school until I left for college so it was all that I knew. But still, I was raised to have my own faith, my own beliefs, my own opinions. Being part of a family with almost 75 people, I am constantly surrounded by support and love, and faith. I was raised to trust, hope, and love beyond myself."

Isabella C.
BETHLEHEM, PA
09 DEC 2020

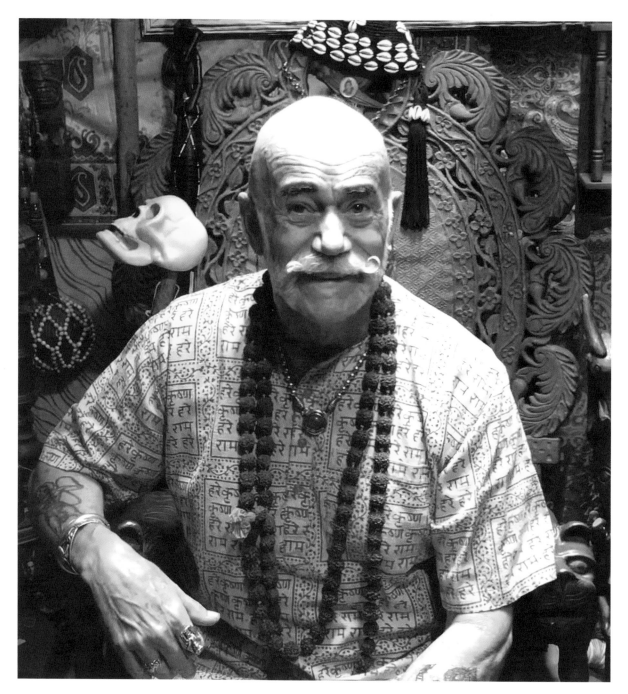

"**I TOOK A RISK WHEN** in the 1960's I left for India from San Francisco as a young archaeologist, and you can see what happened to me: I became a Hindu Swami. I really went over there as a scientist to study at various archaeological sites, and in the process, I met one of India's greatest saints, who initiated me as a priest in the Hindu religion. And I've been on this path now for over 60 years."

Dr. Kenneth K.
Age 69 / TV Expert, Professor
LAS VEGAS, NV
13 JAN 2020

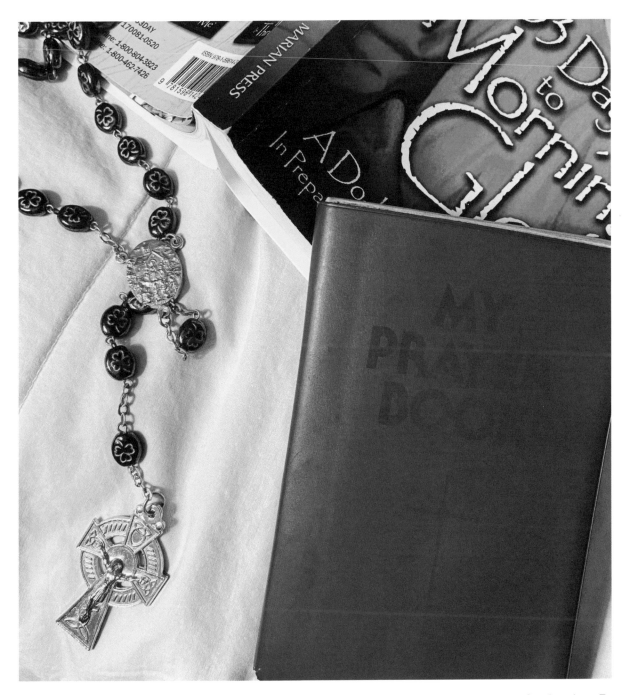

"AT THIS POINT IN MY LIFE I no longer feel the need to justify my Catholic beliefs. To paraphrase the words of St. Thomas Aquinas, 'For those who believe, no explanation is necessary. For those who do not, none will ever be enough.'"

Catherine B.

Age 57 / Temporary Caregiver

GROSSE POINTE, MI
12 JAN 2021

"THE TRADITION I CARRY ON IS . . . salah, or prayer. Praying together is important for us and our family."
NABILE S. — ALPHARETTA, GA

"AT THIS POINT IN MY LIFE I have worked really hard to erase a lot of what I was raised to believe. I try not to believe much. I like to experience and to know." ARTURO S. — PHILADELPHIA, PA

"I WAS RAISED TO BELIEVE that I can be anyone I want to be, I can be anything I want to be. I was also raised to believe that it's important to not think just about myself, but to live a life of service." HANNAH W. — SEWANEE, TN

"THE TRADITION I CARRY ON IS . . . during the Jewish holiday of Hanukkah is the lighting of the Menorah . . . There was enough oil to have the Menorah lit for one day, but a miracle happened. The Menorah stayed lit for eight days, and that's why we celebrate Hanukkah for eight days." JEWCRAZY T. — BROOKLYN, NY

Images by Cheryl Hess

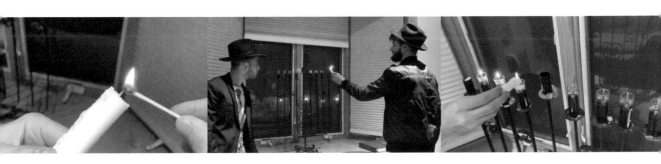

"**THE TRADITION I CARRY ON IS** faith in a God who loves all people. My sweet Grandma Weezie taught Sunday School to children at our little church for 65 years without ever taking a break. She taught everyone from her oldest daughter to her youngest great granddaughter. She'd lead us in singing 'Jesus loves the little children, ALL the children of the world.' That is a tradition I carry and spread on, which is to love everybody."

Debi M. ‹

OKLAHOMA CITY, OK
15 JAN 2020

"**I WAS RAISED TO BELIEVE** that faith does not just mean visiting your local temple, but also putting your faith's principles into action in your daily lives. One of the core tenets of Sikhism, the faith with which I identify by, is the idea of 'Seva.' 'Seva' means serving others in times of need with no expectation of anything in return . . . Our parents and extended family constantly taught my older brother and I to always serve the community around us however possible."

Anonymous ∧

WILSON, NC
23 JUL 2020

"**I WAS RAISED TO BELIEVE** in Islam. Although over time when I grew up just being in a strict religious household kind of made me move away from that . . . I like to call myself a possibilinist, because I believe in multiple possibilities, like we don't have the answers to specific questions and we just have to use science to figure out what is true and what's false."

Fahmi A.

PALOS HILLS, IL
22 JAN 2020

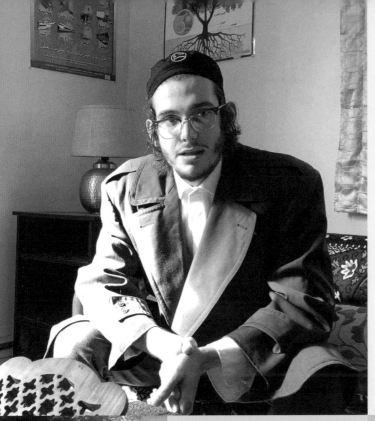

"I WAS RAISED TO BELIEVE that religion and a relationship with God was an extremely important part of a person's life . . . I didn't want religion just to be a part of my life. I wanted it to be my whole life. For me, there was always the question of there either is ultimate truth, and so your life revolves around it, or there's not."

Adam S. ‹

MISSOULA, MT
06 DEC 2019

"I WAS RAISED TO BELIEVE in the power and knowledge of my ancestors. I am a black woman who came from the city with the largest black population in Brazil and my religion which is Candomblé is a big part of who I am. Candomblé is an Afro-Brazilian religion that teaches us how to deal with the harshness and beauty of life. Teaches how to live in community since a very important pillar is family and how to respect each other. Now I live in the USA but that doesn't change the fact that my beliefs go with me wherever I go."

Genise Z. ‹

BRONX, NY
26 AUG 2020

"YOU DON'T KNOW WHAT IT'S LIKE TO be an interfaith leader, going to a church or a religion that's different from yours and trying to build bridges."

Akir K. ∧

GREENSBORO, NC
01 APR 2020

Image by Sana Haq

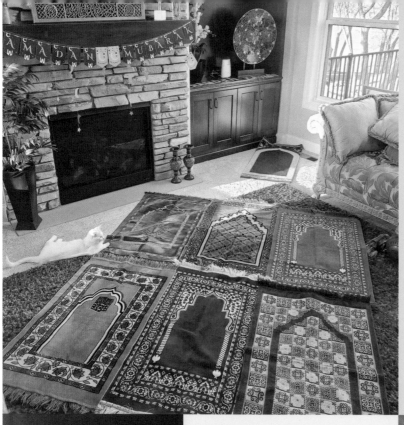

"I NEVER EXPECTED to create a mini-mosque in my home. I never expected to pray only with family. I never expected my son to lead me in prayer. I never expected my cat to be my Taraweeh buddy. I never expected to appreciate and be grateful for my health, home and privileges. Blessed to find peace, reflection and connection during a COVID-19 Ramadan."

Nausheena H. <
MINNEAPOLIS, MN
18 MAY 2020

"I NEVER EXPECTED as a rabbi I would be delivering matzah, the unleavened bread for Passover, to Jews in Big Sky Country in the beautiful state of Montana, wearing a mask and gloves and keeping distance from people . . . instead of having our big public Seder, with hundreds of people coming through our doors . . . We do whatever God puts on our plate. So if right now, that's how he wants us to celebrate Passover, that's how we do it."

Chaim B. <
BOZEMAN, MT
06 APR 2020

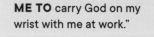

"MY PARENTS WANTED ME TO carry God on my wrist with me at work."

Jose D. ∧
STATEN ISLAND, NY
13 DEC 2019

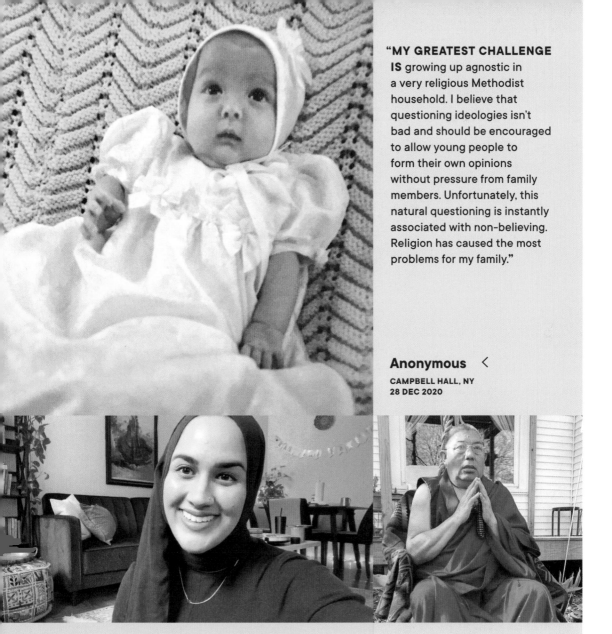

"MY GREATEST CHALLENGE IS growing up agnostic in a very religious Methodist household. I believe that questioning ideologies isn't bad and should be encouraged to allow young people to form their own opinions without pressure from family members. Unfortunately, this natural questioning is instantly associated with non-believing. Religion has caused the most problems for my family."

Anonymous ‹

CAMPBELL HALL, NY
28 DEC 2020

"I WAS RAISED TO BELIEVE the whole world is a mosque. Meaning, I can have a spiritual experience and connect with Creator from anywhere in the world."

Kifah S. ⌃

NEW YORK, NY
18 MAY 2020

"THE TRADITION I CARRY ON IS . . . This is the tradition I carry on, despite coronavirus."

Geshe T. ⌃

FAYETTEVILLE, AR
24 APR 2020

"I NEVER EXPECTED the hatred and the vitriolic backlash that we received from keeping our doors open." GREG L.— MOUNT JULIET, TN

"What keeps me up at night is regret. Due to a mistake and decision I made. The sorrow, that it gives me all the time. The guilt I feel. But I pray every night and day for forgiveness. I pray for the healing for the mistake I made."

Anonymous
MOUNT PLEASANT, PA
01 MAY 2020

"I WAS RAISED TO BELIEVE that things in this world don't just happen by chance. That it's synchronicity, and what we call divine Providence and everything that takes place. And I personally experienced it in amazing ways out here in Hawaii . . . about 15 years ago . . . I ended up meeting fellow Jewish people out here in . . . the furthest part of the world. We've created a community, which we call gunny, which means the divine garden . . . And it was all divine Providence and this amazing synchronicity."

Michoel G.

Age 44 / Rabbi-Educator-Publisher / Gani — Kauai Jewish Center

KAPAA, HI
11 DEC 2019

"I WAS RAISED TO BELIEVE that it is very important not to ever hurt anyone. I distinctly remember when I was young, my Dad said, 'Never make anyone cry.' That stuck in my head for a long time. Over time I would remember examples of when he was in India and he was poor, he did not have anything. I'm guessing others would hurt him with that, even though they knew that he needed money but they wouldn't give it to him. That still bothers my Dad to this day. I always have to constantly watch, 'Am I hurting someone?' It's like a constant tape recording going on, because I remember that pain that he had when he was growing up."

Praveen Y.

Age 50 / Accountant

ODESSA, TX
04 DEC 2019

"I WAS RAISED TO BELIEVE in the Mormon faith, and as I've grown older and asked myself unpopular questions, I've come to realize nothing I learned as a child was true. My parents have completely alienated me and none of my five other siblings believe in it anymore. I recently had to cut my mom off because she has been manipulating me and it only took leaving the faith to realize it. It's been really hard trying to talk to them about this because they don't listen. They only want to project their beliefs onto me, but don't want to listen to mine."

Anonymous

REXBURG, ID
17 SEP 2020

"THE TRADITION I CARRY ON IS my practice of Buddhism. Although Buddhism has been in my families for generations, I did not understand it until about fifteen years ago . . . Buddhism has changed my life, I do not look at life the same way again. I was lost in a world of emotions and feelings, of greed, anger, hatred, and jealousy but I am now a new person. I can see life as it is and I have a much happier and more peaceful life. Buddhism teaches about the mind, your mind, my mind, everyone's mind. Understanding how your own mind works is the greatest gift of all and I urge you to investigate it, to know your own mind."

Sothy T.

A Buddhist Tradition

OVIEDO, FL
06 OCT 2020

wo

"Dish-washers,
Elevator-boys,
Ladies' maids,
Crap-shooters,
Cooks,
Waiters,
Jazzers,
Nurses of babies,

Loaders of ships,
Porters,
Hairdressers,
Comedians in vaudeville
And band-men in circuses—
Dream-singers all,
Story-tellers all."

—Langston Hughes

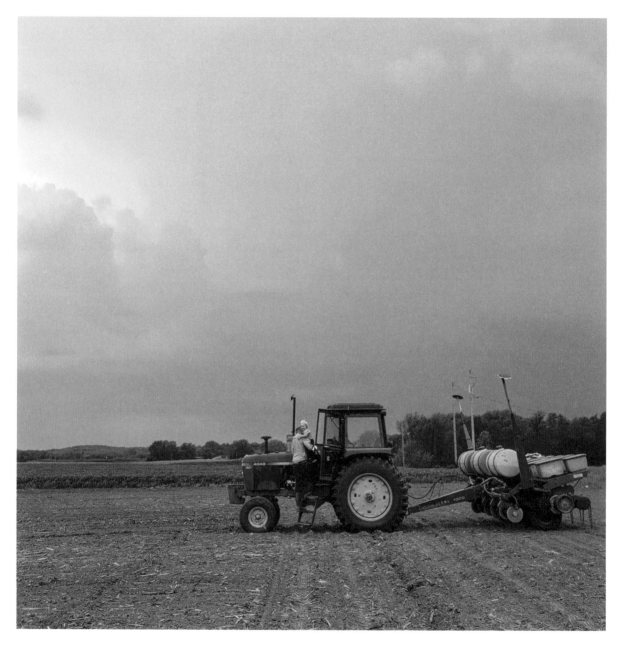

"**I NEVER EXPECTED** to be a mom or a dairy farmer. Both jobs are so completely consuming and I struggle to find balance. I love my boys and I love caring for the cows and land entrusted to our family. I can't imagine a different life, but I'm tired. Some days I feel like I am failing and then the next day things work out ok."

Carrie M.

Age 38 / Dairy Farmer

JOHNSON CREEK, WI
05 JAN 2021

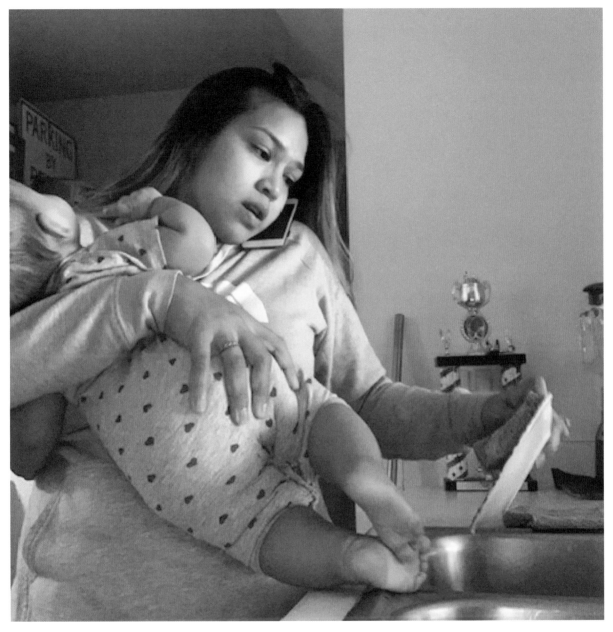

"A DAY'S WORK IS making sure my infant is fed and ok. Making sure my house is clean and organized. Making sure our bills are paid and up to date."

Natali F.

Age 28 / Stay at Home Mom

MADISON, WI
24 DEC 2019

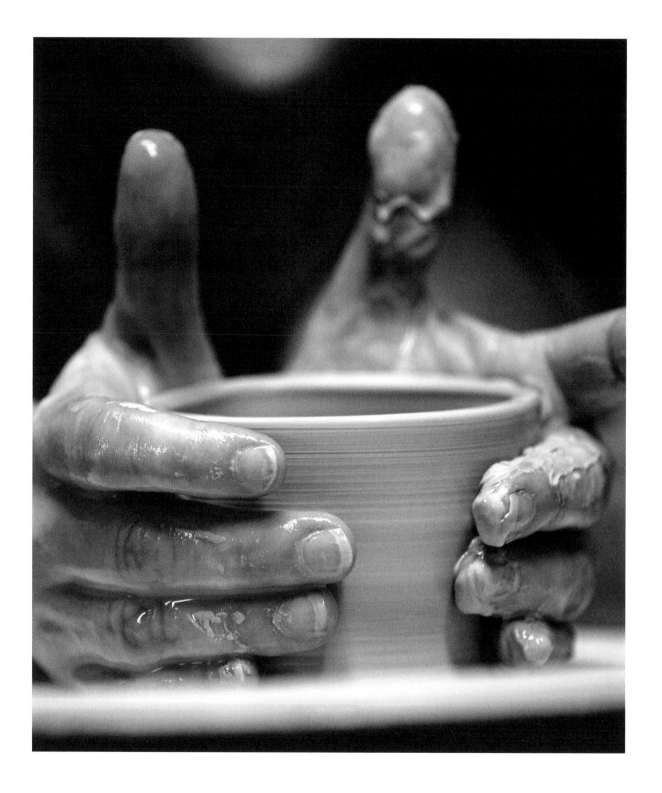

"To me work means getting out of bed every single morning loving what you're doing to create a life for yourself . . .

I have endured multiple lifetimes of poverty, tragedy, heartbreak and loss. For a long time I let those things define who I was as a person and I allowed those emotions to run my life for me. Today, I'm at the realization that if I do not get up every single day with the purpose and intent on creating a beautiful and better life for me, I will never have the life I want . . . My artwork gives me purpose and beauty at once."

Ashlynn Z.

Age 28 / Freelance Ceramicist

CLAYTON, DE
22 SEP 2020

Image by Jane Therese

To me, work means EVERYTHING . . . I eat, sleep and breathe it and I want to be known as one of the best that's ever done it . . .

The long hours, the aches and pains, the feeling of success in a job well done . . . it's all part of it. I've put my heart and soul into the plumbing trade and it has paid off tenfold. I'm fortunate to be doing what I love and most importantly what I feel I am meant to be doing."

Christopher H.
Age 30 / Journeyman Plumber
MAPLE VALLEY, WA
3 OCT 2020

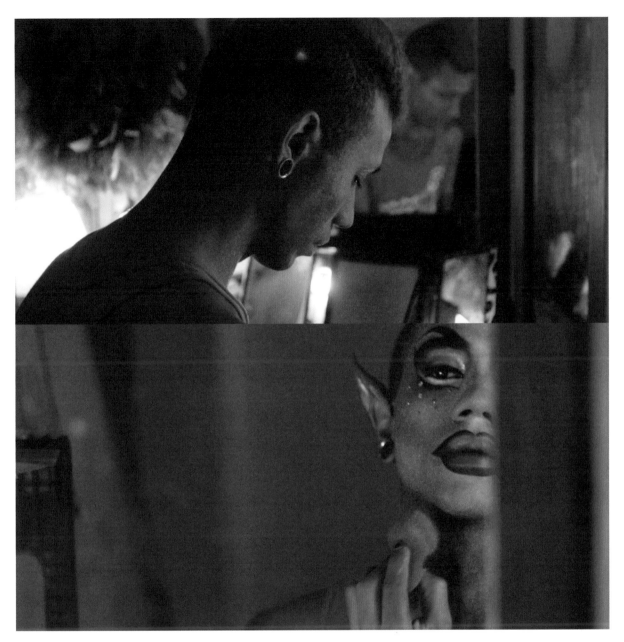

"TO ME, WORK MEANS . . . When I wake up, I think about, like, drag. When I go to sleep, I think about it. It's my job. It's my identity. It's my wellbeing. All of my money comes from drag. Some professions you can separate from your identity, but this profession is my identity."

Maxi G.
SAINT LOUIS, MO
09 NOV 2020

Images by Zia Nizami

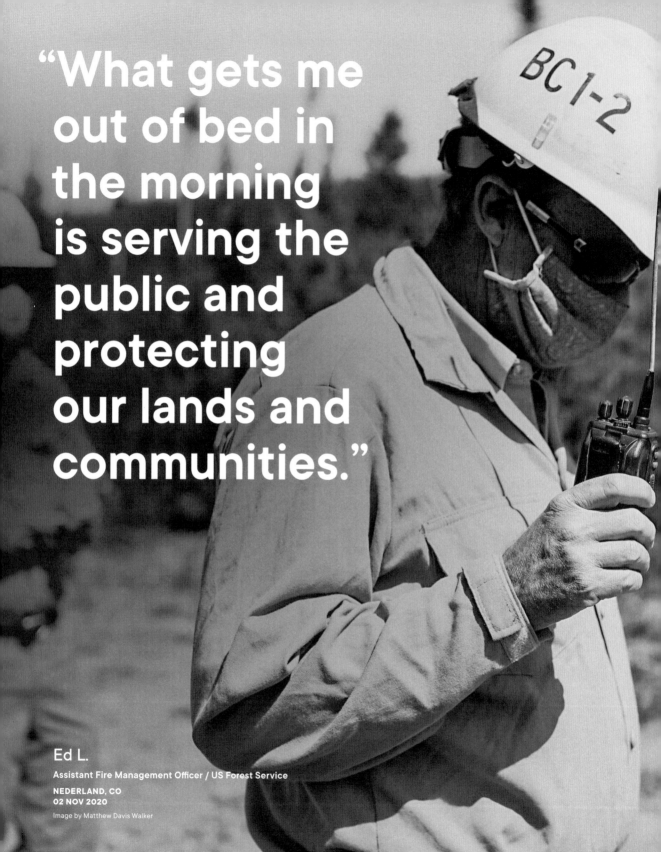

"What gets me out of bed in the morning is serving the public and protecting our lands and communities."

Ed L.

Assistant Fire Management Officer / US Forest Service

NEDERLAND, CO
02 NOV 2020

Image by Matthew Davis Walker

"I took a risk when we opened up a coffee shop . . . My oldest son has Down syndrome and we wanted a business where we could foster his growth and have him work and earn his own pay and give back to our community.

It was risky for us because, I knew I liked coffee, but I didn't know anything about making coffee. So here we are going on year five and it's been a wonderful experience for us . . ."

Matt M.

Age 48 / Coffee Shop Owner
BISMARCK, ND
22 JAN 2020

"**I TOOK A RISK WHEN** I left corporate America six years ago to start my own business. I needed to take control of my life, my time, my finances and create space for ME and my family in this world. It was terrifying transitioning from the comfort zones of corporate America to the unknown water of entrepreneurship. Like a flower I bloomed, and alongside my clients, assisted them in creating and telling their love story narrative through wedding planning and design. I look back and wonder, what took me so long? Never be afraid to take a risk, as the rewards could outweigh them. Live free, live bold and remember that life is a journey and to always trust the journey."

Michelle N.
Age 40 / Wedding and Event Planner /
Michelle Norwood Events

NEW ORLEANS, LA
10 JUN 2020

Image by Mo Davis

"WHAT GETS ME OUT OF BED IN THE MORNING IS knowing that I am an essential worker. I work in a grocery store, although it can get pretty hectic during this time. I feel like essential workers don't get the appreciation they deserve. From time to time I get a simple 'Thank you for working today' or 'I appreciate you for coming in.' It always makes my day even if it's only one person saying it. I know it worries my mom that I could be potentially at risk every time I go but it's worth it to be helping others get and find their essentials."

Arendy T.

Age 17

PROVIDENCE, RI
01 MAY 2020

"TO ME, WORK MEANS looking out for my workers and reminding them to look out for each other. Together we contribute to building a better city by impacting its growth and building more opportunities for our community."

Jorge C.

Age 25 / Construction — Utilities

SAN ANTONIO, TX
06 AUG 2020

"You don't know what it's like to be a registered nurse standing at a patient's bedside witnessing their last exhale.

Feeling their rapid and thready pulse fade out. Holding their hand, escorting them as they slide quietly into death. Their physical body gently grays and their senses dim. Perhaps the jaw slackens. As miraculous as birth, this profound encounter of their end. We nurses lean in to comfort the dying then cry with the family. We pray in every faith or none. We wash the body and place it in a shroud. Then, before the morgue gurney disappears from sight we hustle to the living who are ringing their call bell for our attention. This is our calling."

Susan T.

Registered Nurse

LANEXA, VA
13 FEB 2020

"I NEVER EXPECTED to be a nanny, but when COVID-19 hit and I lost my photography jobs, I had the opportunity to nanny two young girls for the summer. It was one of the most enlightening and positive experiences I could have hoped for from this whole ordeal. They brought so much light and positivity to my life and outlook on the world."

Stephanie S.
Age 31 / Photographer
**WEST RICHLAND, WA
09 OCT 2020**

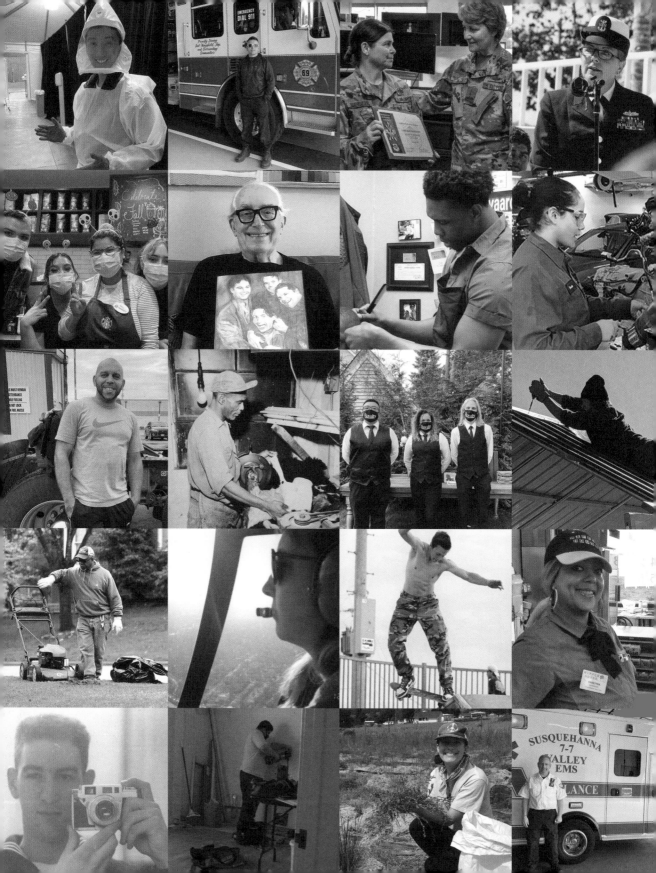

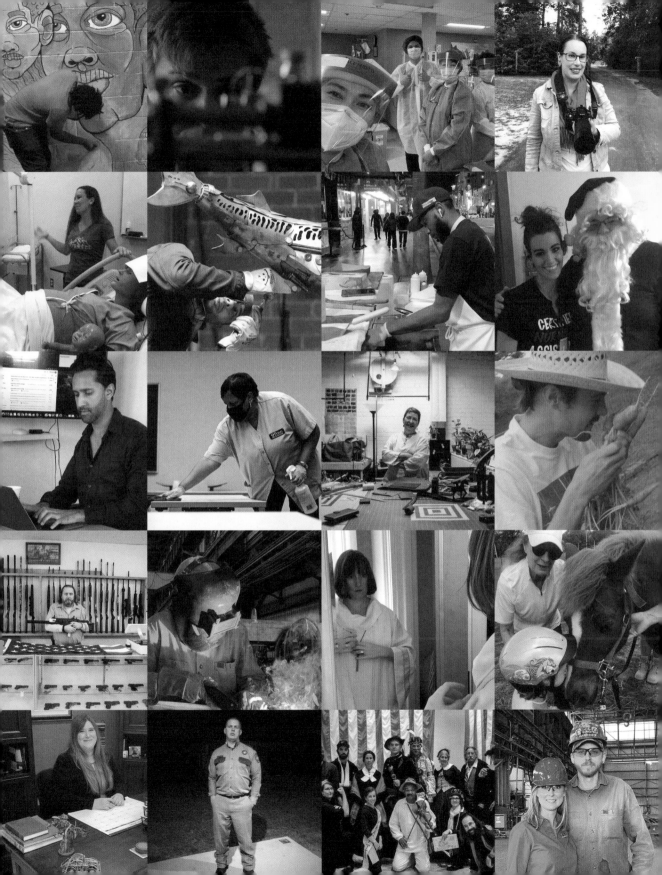

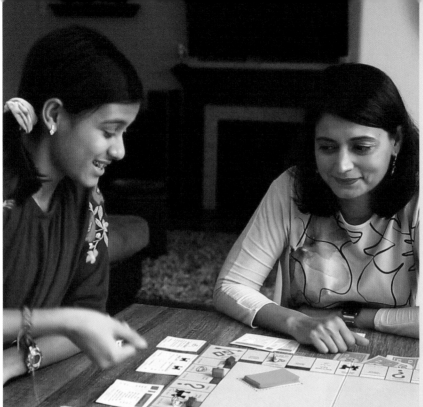

"A DAY'S WORK IS . . . My typical day would involve seeing patients in clinic. Coming back home you switch back completely to your mom role. First, it's about getting dinner on the table. After that, sitting down with them and making sure all the homework's done. After that we try to do some family time. That's what it's about at home, after work."

Sameea S. <

SUMMERFIELD, NC
01 MAY 2020

Image by Sana Haq

"I TOOK A RISK WHEN I went inside a burning house to save someone."

Ladd S. ∧

MCKINNEY, TX
10 JAN 2020

"I NEVER EXPECTED . . . My grandfather, Sinclair Clark, (1902–1999) was highly respected in the taxidermy industry . . . From the late 1920s onward, his services were in great demand by prestigious museums, collectors, and taxidermists all over the United States."

Diane P. ∧

BRONX, NY
24 JUL 2020

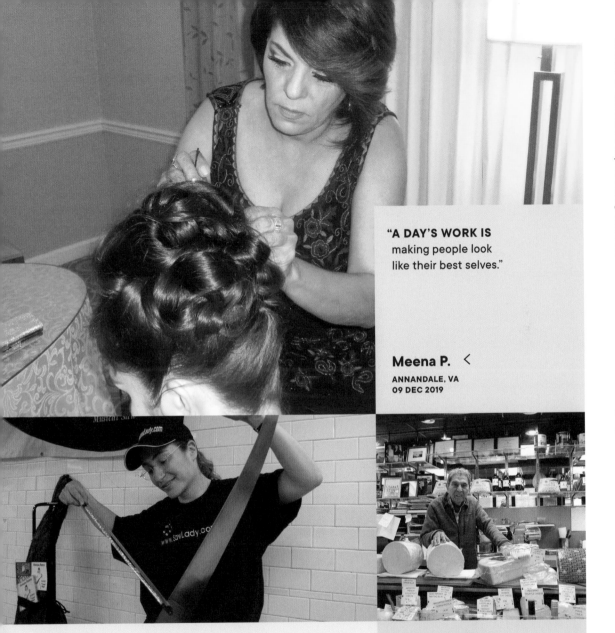

"**A DAY'S WORK IS** making people look like their best selves."

Meena P. ‹

ANNANDALE, VA
09 DEC 2019

"**A DAY'S WORK IS** being part of the goings on in the streets, to be one small piece of the world. I'm a busker (subway musician) . . . Many people erroneously think buskers play in the street because we're homeless, or we can't find a job or because we're not good enough to be invited to perform on stage. This couldn't be farther from the truth: I don't HAVE to play in the subway . . . I CHOOSE to play in the subway."

SawLady P. ∧

ASTORIA, NY
15 JAN 2020

"**A DAY'S WORK IS** behind the counter of my Italian market."

Antonio D. ∧

PROVIDENCE, RI
24 MAR 2020

Image by Giuliana Guarino

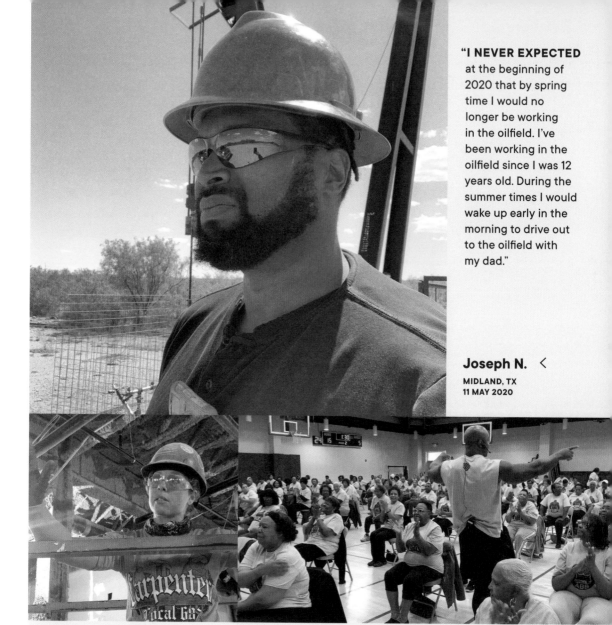

"I NEVER EXPECTED at the beginning of 2020 that by spring time I would no longer be working in the oilfield. I've been working in the oilfield since I was 12 years old. During the summer times I would wake up early in the morning to drive out to the oilfield with my dad."

Joseph N. ‹
MIDLAND, TX
11 MAY 2020

"TO ME, WORK MEANS pride. As a union carpenter, we are the first one in and the last ones to leave. Something you can be so proud to do . . . You may be tired from work, but you're very proud of it."

Traci Ann L. ⌃
CLINTON TOWNSHIP, MI
01 SEP 2020

"MY GREATEST CHALLENGE IS, as a senior fitness instructor, making sure that I create an innovative senior workout that can gain the interest of all the seniors in my surrounding area."

DeShaun J. ⌃
DECATUR, GA
04 NOV 2019

"**MOST DAYS I FEEL** pretty fortunate that I get to run a restaurant with my brother and sister, get to feed my community, host parties, cook my favorite foods— it's everything I want to do."

James C. <

ARABI, LA
14 NOV 2019

"**A DAY'S WORK IS** leaving something better than when you started in the day. I feel lucky I get to work outside with people I know and care about. I feel safer outside and I know I am doing my part to keep others safe too. Every job, from roadwork to seed harvesting, directly helps the community of this beautiful place. I am so glad I get to feel like I am making a difference no matter what the work is. Regardless of the state of the world, that's important, and not something everyone gets to experience. I am lucky and I'm happy to be working out here."

Kate G. <

PETROLIA, CA
27 AUG 2020

"**TO ME, WORK MEANS . . .**
I think the best part of my job is knowing that I accomplished something every day by delivering goods across the country and you never go home not satisfied with what you did for the day."

Anonymous ^

BETHESDA, MD
30 SEP 2020

"In America, work isn't just what you do, it's who you are."

Francis J.
NEW YORK, NY
08 DEC 2020

"WHAT GETS ME OUT OF BED IN THE MORNING IS my forty year affair. This is not a love affair but it is passionate, nonetheless. My love is teaching English literature to working class college students in NYC at CUNY."

Maryann F.
NEW YORK, NY
27 APR 2020

"A DAY'S WORK IS to begin another adventure in rescuing an abused, neglected, old or worn out piece of furniture. You may ask why do I bother? Because it matters to me to save them. I can't save the world but I can save furniture!"

Dominique G.
STRATHAM, NH
06 APR 2020

"A DAY'S WORK IS challenging, rewarding, heart-breaking, hopeful, discouraging, and miraculous all at the same time. I am a social worker who works in our jail systems to connect people with mental health services when they are released. Working in these systems I get to see the best and worst of humanity on a daily basis, and don't assume the worst of humanity is the people behind the bars in jail, it's not. This year has been tough to say the least."

Anonymous
DENVER, CO
29 DEC 2020

"MY GREATEST CHALLENGE IS working away from the house full time and making sure my kids are getting their school work done through e-learning. It's difficult being an essential worker while having school children at home without their parents being able to help them."

Paula C.
ROSELLE, IL
10 MAY 2020

"AT THIS POINT IN MY LIFE I have found myself starting a new career. Coming home from college with an extended break I have chosen to find a winter job as an oyster farmer. I have learned so much about the challenges of a Bayman and the work that is put into each oyster and how the process works from farm to table. Without covid-19 I wouldn't have experienced these challenges and built the respect I have for the blue collar worker."

Jack H.
SOUTHAMPTON, NY
02 JAN 2021

"TO ME, WORK MEANS we get to use a part of ourself and our skillset to serve and help others in exchange for income, but I do not view work as my identity—just another aspect of what I can offer the world."

Steve S.
NEW YORK, NY
04 AUG 2020

COMM

"The greatness of a community is most accurately measured by the compassionate actions of its members."

—Coretta Scott King

UNITY

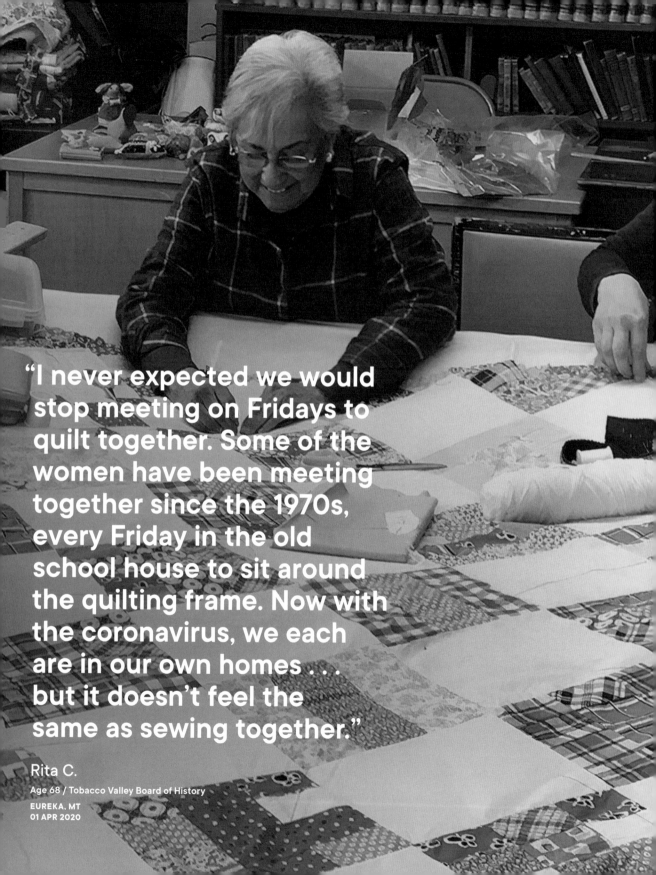

"I never expected we would stop meeting on Fridays to quilt together. Some of the women have been meeting together since the 1970s, every Friday in the old school house to sit around the quilting frame. Now with the coronavirus, we each are in our own homes . . . but it doesn't feel the same as sewing together."

Rita C.

Age 68 / Tobacco Valley Board of History

EUREKA, MT
01 APR 2020

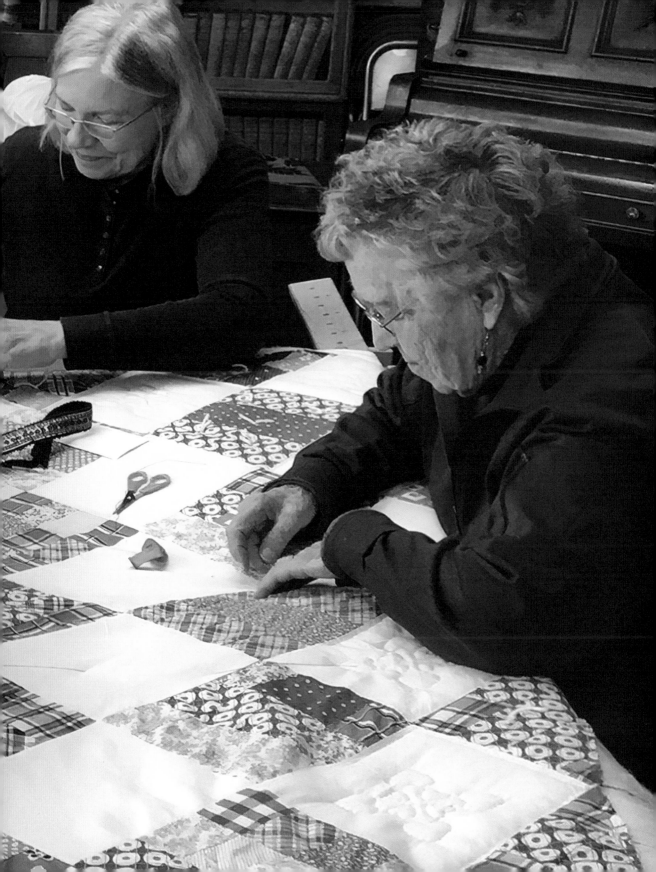

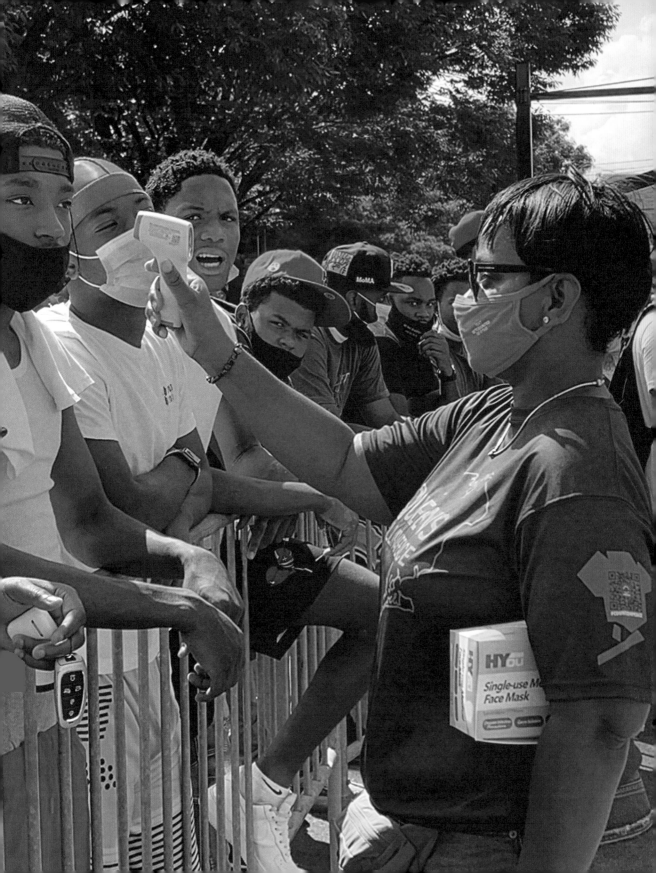

"In our community, we die more than people in underserved countries. And it is because of that I stay dedicated—in the days, in the nights, when people are asleep, we are out here on these streets."

Erica F.
CEO / Lifecamp Inc
JAMAICA, NY
28 JAN 2021

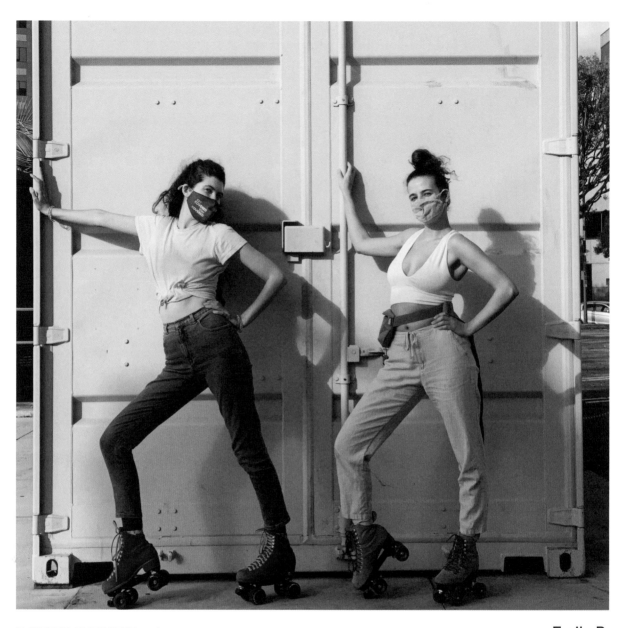

"**I NEVER EXPECTED** to become an enthusiastic roller skater past age thirty. But during the pandemic, after spending months cooped up in my apartment, I was desperate to try something new. Before, my husband and I used to go dancing often—the experience of moving in a crowd of people was a source of such potent joy. And it turns out that roller skating flips a lot of those same mental switches! My roller skating community is incredibly welcoming and safe, and when I strap on those wheels and start gliding, to 60s funk, 80s disco, whatever strikes our fancy, I feel connected to my body's potential for bliss in such an incredibly powerful way. Finding a way to simply be with others, to gather and dance and celebrate being alive during this time of stress and separation has been a true and surprising gift."

Emily B.

Age 31 / Author

LOS ANGELES, CA
27 JAN 2021

"MY SATURDAY NIGHT LOOKS LIKE . . . My Saturday night is filled with reading these days. I've never been much of a partier. I'd rather curl up with a good book than paint the town red."

Varena H.

Age 73 / Retired Teacher

GRAFTON, WV
10 JAN 2020

"THE TRADITION I CARRY ON IS the magic of community theater. When the longest continually running community theater in Oklahoma City had to move from the space it had held for 64 years many people questioned whether to bother to try and move it and others thought even if we did, it wouldn't make it. Luckily I was helped by our amazing theater community and we were able to take an old school gymnasium, and move the theater and 64 years' worth of costumes and props and lights and transform it into a beautiful theater. We've only had one show so far (small audiences socially distanced and masked) but it went off flawlessly and Jewel Box Theater will see its 65th year after all. PS We also keep the tradition of the leaving the ghost light on at night."

Darron D.

Production Director /
Jewel Box Theater OKC

**OKLAHOMA CITY, OK
28 JAN 2021**

PBS AMERICAN PORTRAIT : COMMUNITY

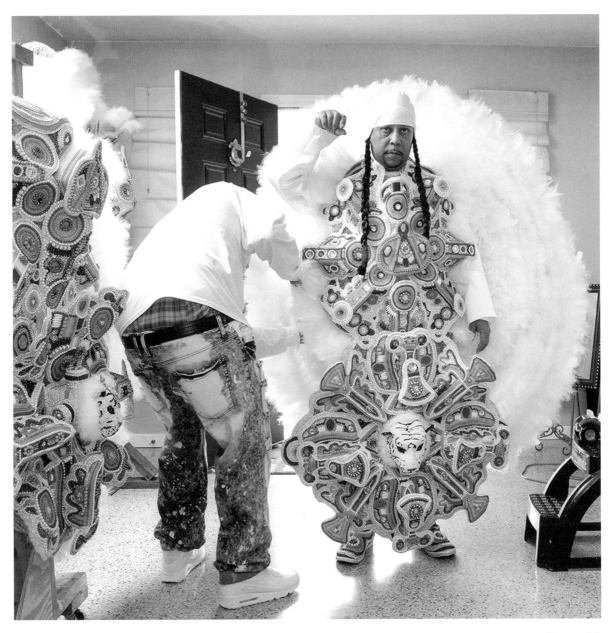

"WHAT GETS ME OUT OF BED IN THE MORNING IS the call of Mardi Gras Day. To most people Mardi Gras is just another Tuesday, but in New Orleans it is the spectacular conclusion of Carnival. Participants labor throughout the year making costumes and sewing new suits for Fat Tuesday, and when that day arrives they put it all on and parade through the city streets. Converging on the French Quarter the community carries on old traditions while making new ones in their wake. It is a beautiful and heavy day that can make the heart ache, while renewing our soul for another year."

Ryan H.
Age 38 / Photojournalist
NEW ORLEANS, LA
11 FEB 2020

"I WAS RAISED TO BELIEVE in giving back to the community. Once I retired my wife and I both figured this is a great way to give back by volunteering here at the Oregon Humane Society . . . We can be a voice for the animals that don't have a voice otherwise."

Tim H.

Retired & Volunteer /
Oregon Humane Society
PORTLAND, OR
10 DEC 2019

"WHAT GETS ME OUT OF BED IN THE MORNING IS curating my poetry fence for my community. Sharing poems for children and adults on my fence, staking laminated poems in my neighborhood. I share poems on a mini poetry fence in my local library, place neighbors' poems in capsules in a gumball machine in a local cafe during National Poetry Month. People tell me they come to my poetry fence for solace and inspiration, that their children gorge on cherry tomatoes I plant in the parking strip."

Renée A.

Age 70
ALEXANDRIA, VA
21 AUG 2020

"I took a risk when I decided to bring the arts to my little rural NM town. There were many, many sports programs but no community arts program for anyone of any age . . . Covid-19 hit us pretty hard. We suspended our programming but the kids didn't want to stop singing, so we moved the chorus on-line. We re-created our program . . . Not sure what comes next, but I know we will keep fighting to enrich our community through art."

Neal S.

Rio Rancho Youth Chorus,
Rio Rancho Players, Squeaky Shoe Project
RIO RANCHO, NM
12 JAN 2021

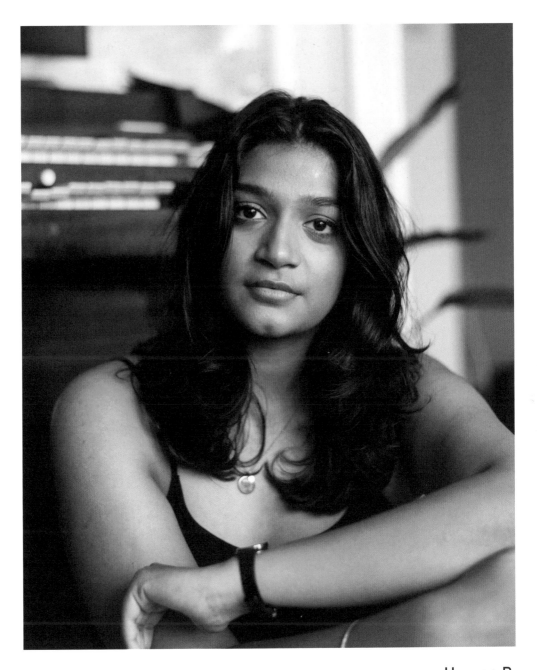

"YOU DON'T KNOW WHAT IT'S LIKE TO balance two different identities and not really belong to one community."

Upasna B.

Age 23 / Graduate Assistant & Student

EVANSTON, IL
10 JAN 2020

"I NEVER EXPECTED when I created my gnome garden during lockdown that it would be a source of joy and hope, a gift for the neighborhood. I began to notice kids on our street stopping by. Then kids and adults. Then neighbors from surrounding streets I had never met. I would hear from other neighbors how often folks would visit. Some daily. Many comments on how much the garden was enjoyed were shared with me . . . Finally at Christmas, a family we'd never met left this card and a box of chocolates in our mailbox. The joy and hope their kindness brought me, knowing a simple gnome garden meant so much to others during these challenging times, uplifted me and became the best gift of all."

Lisa C.
Actor / Storyteller
WESTPORT, CT
10 JAN 2021

PBS AMERICAN PORTRAIT : COMMUNITY

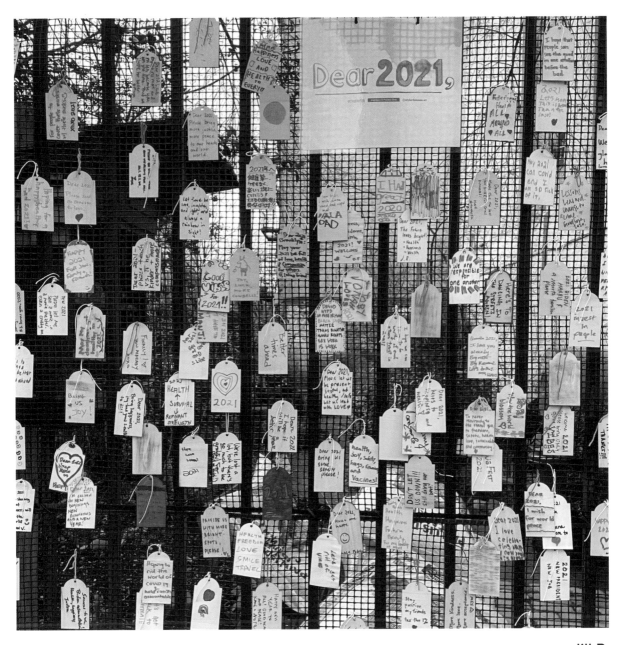

"MY GREATEST CHALLENGE IS having hope for the future during this worrisome time. When I stumbled upon the neighborhood children posting their wishes for 2021 on the fence at my local community garden, I was reminded that hope still exists and will always exist. It is what leads us out of despair."

Jill B.
BROOKLYN, NY
12 JAN 2021

"MY SATURDAY NIGHT LOOKS LIKE lots of laughter with lifelong friends." MATT B. — NORWOOD, MA

"WHAT KEEPS ME UP AT NIGHT IS . . . I am part of a much greater movement of agrarians. I believe our work with the earth radiates outward from the individual, with the potential to heal relationships within our human communities and our collective connection to the natural world."

Carmen T. ‹

CHAMA, NM
10 DEC 2019

"A DAY'S WORK IS providing much-needed social, emotional, and academic services to our youth in the community."

Presilla K. ᐱ

LOS ANGELES, CA
11 NOV 2020

"MY SATURDAY NIGHT LOOKS LIKE . . . I was in my backyard doing spring cleanup, heard neighbors on both sides doing the same. I shouted across the fence, 'Do you want to meet in my driveway at 5:30 for a drink and social hour?' . . . They in turn invited their neighbors . . . some had never met before . . . The pandemic has brought our neighbors outside, and we look forward to every single Saturday night . . ."

Victoria P. ᐱ

BOISE, ID
16 DEC 2020

"THE TRADITION I CARRY ON IS continuing to uphold the legacy of my beloved Alpha Kappa Alpha Sorority . . . It has introduced me to an amazing sisterhood where I have and continue to make lifelong friendships as well as the ability to create a sustainable impact on my community and the entire world."

Aubrey W. ‹

SAINT LOUIS, MO
06 NOV 2020

"WHEN THIS IS OVER . . . I will wear my king costume and go out to medieval and renaissance festivals to entertain people again. Stay strong folks, the King of the North is coming out soon!"

Ned S. ⌃

CHARLOTTE, NC
19 APR 2020

"WHEN THIS IS OVER . . . I understand that we are just in an intermission, and I am hopeful that the day of being able to gather and celebrate together again will come soon."

Courtney M. ⌃

ARLINGTON, VA
03 DEC 2020

"YOU DON'T KNOW WHAT IT'S LIKE TO finally find a place where you belong." LILY N. — WILMINGTON, NC

"When I step outside
my door, I see Detroit.
I see my neighborhood,
with its character, its
history, its houses. I see
the streets, filled with
cars and community.
I see the blue skies of a
Michigan summer. I see
downtown. I see buses,
that a whole city relies
on. I see construction,
and change. I see art,
and I see emptiness.
But I see home."

Devon M.
DETROIT, MI
14 JUL 2020

"THE TRADITION I CARRY ON IS . . . Football means a lot to this town, means a lot to our community. It means a lot to our city. It means a lot to our kids. The stadium is a special place. Paul Brown built this stadium and on Friday night in the fall, 10,000 fans line the seats and watch their Tigers take the field. It's a symbol of hope. It's a symbol of the life of this community and it's the future in a lot of ways for our players. And it's our job to do everything that we can to make sure they have this experience this season. Go Tigers."

Nathaniel M.

Age 39 / Athletic Director and Head Football Coach / Massillon City Schools

**MASSILLON, OH
21 MAY 2020**

"WHEN I STEP OUTSIDE MY DOOR I see a dismantling of my historical neighborhood. Developers have come in and are buying up the majority of the older single family homes, replacing them with what we pejoratively refer to as 'McDorms.' Essentially, a lot of unofficial off campus frat houses. Such housing is not a conducive environment for raising my son. I shouldn't have to explain to him the piles of empty beer bottles, trash and broken furniture that are the remnants of last night's party left on the front lawn every morning. It's really turned into a different place around here."

Brad F.

Age 40 / Singer Songwriter & Dad

**NORMAN, OK
01 JAN 2020**

"MY AMERICAN DREAM was writing in a motel in downtown Los Angeles about the people I met there. Growing up near London, I was drawn by the truths writers like Kate Braverman and Charles Bukowski found on LA's streets. I did write about marginalized American lives but in Salt Lake City, Utah, rather than Venice Beach, and long-form pieces for an alternative weekly, rather than short stories. On Salt Lake's streets, I met street sex workers, the undocumented and the homeless, and others on the fringes of American life . . . What I've learned from my American dream: the courage and resilience of so many unheralded lives are the golden threads stitching a realm together."

Stephen D.

Age 57

**SALT LAKE CITY, UT
01 DEC 2020**

"I WAS RAISED TO BELIEVE in community. Guam's culture is collectivist in the best way. And while sometimes that environment can feel suffocating, I never forget that family is more than blood—it's the island altogether, and having a community like that at your back will get you through the most."

Ralph P.

Age 23 / Graphic Designer & Fine Artist

**LOS ANGELES, CA
02 MAR 2020**

EQUA

LITY

"In a composite nation like ours, as before the law, there should be no rich, no poor, no high, no low, no white, no black, but common country, common citizenship, equal rights, and a common destiny."

—Frederick Douglass

"What gets me out of bed in the morning is the dream of living in a just and fair world."

Amira K.

Documentary Photographer, Anthropologist and Educator

LOUISVILLE, KY
31 AUG 2020

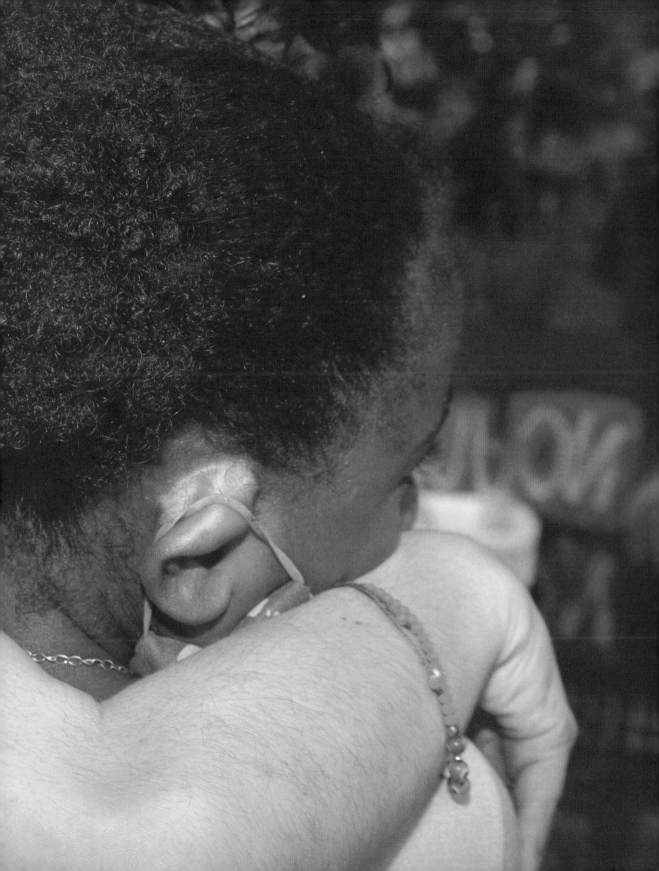

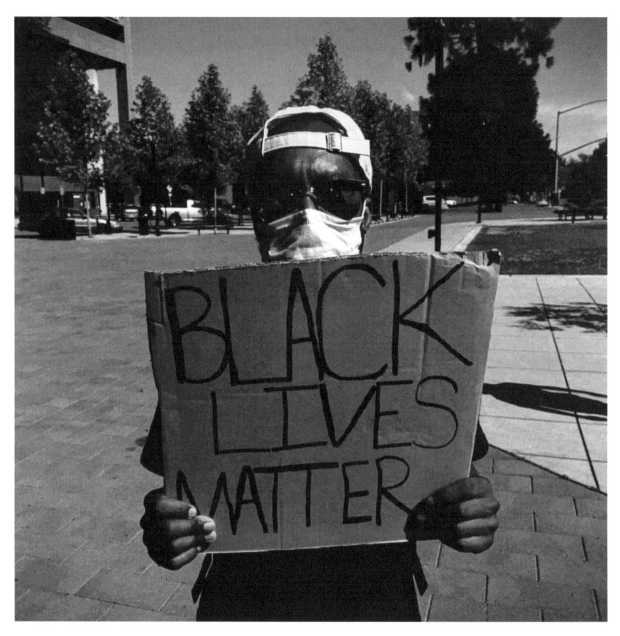

"**NOW IS THE TIME** for the Nation to look back, deep, into the vault that is our American history. To take a moment of genuine reflection into the structures of this country and its founders. The murders of George Floyd, Ahmaud Arbery, Breonna Taylor and many more who fell from the great blows of injustice cannot be forgotten. We must come together and save the soul of this Nation quickly. This can only happen if we can agree on our history—on what has brought us here. If we can look back and grapple with the lack of justice, the lack of equity, and lack of agency over our bodies, and how that has led us to this very time in our history, then, perhaps a full healing can be achieved. Perhaps we can truly have Liberty and Justice for all."

Zaire S.

Age 22

ROHNERT PARK, CA
18 DEC 2020

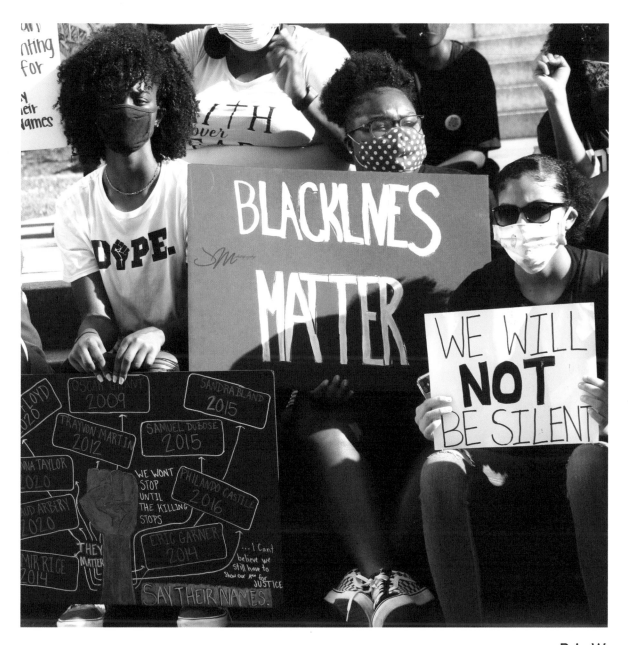

"**I NEVER EXPECTED** to organize and lead a peaceful protest in Mississippi in order to fight for justice and equality for my African American brothers and sisters in America. I never expected that a group of around 150 people, composed of all races, cultures, and ethnicities, would come together as one and demand justice and change in front of the Governor's Mansion in downtown Jackson. I never expected that with a deep, ugly racial past, Mississippi would make history by standing together, as one, on May 31, 2020, to take a STAND against racial prejudice, injustices, and oppression. I never expected for Mississippi to come this far."

Bria W.

Age 25 / Speech-Language Pathologist

MADISON, MS
10 JUN 2020

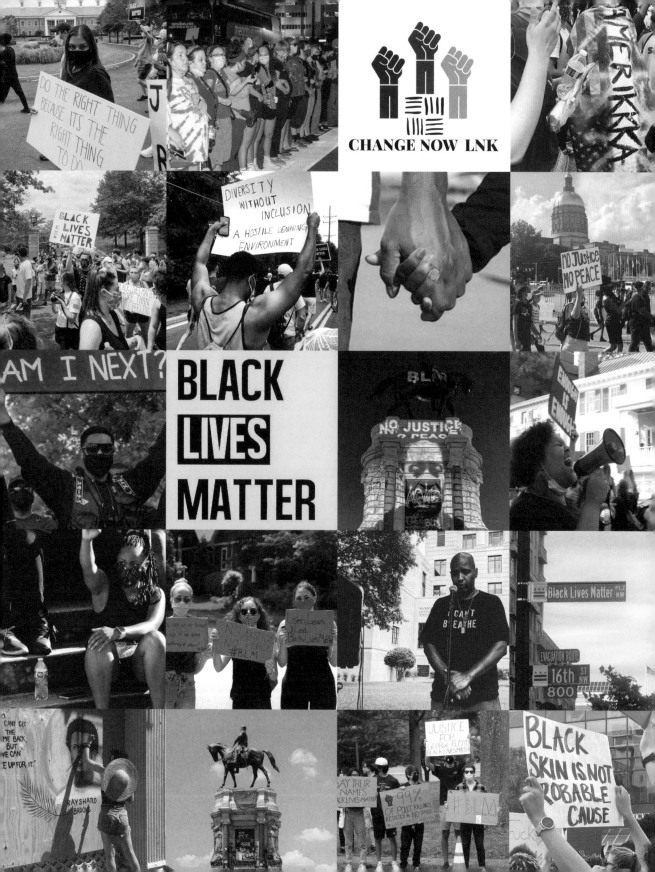

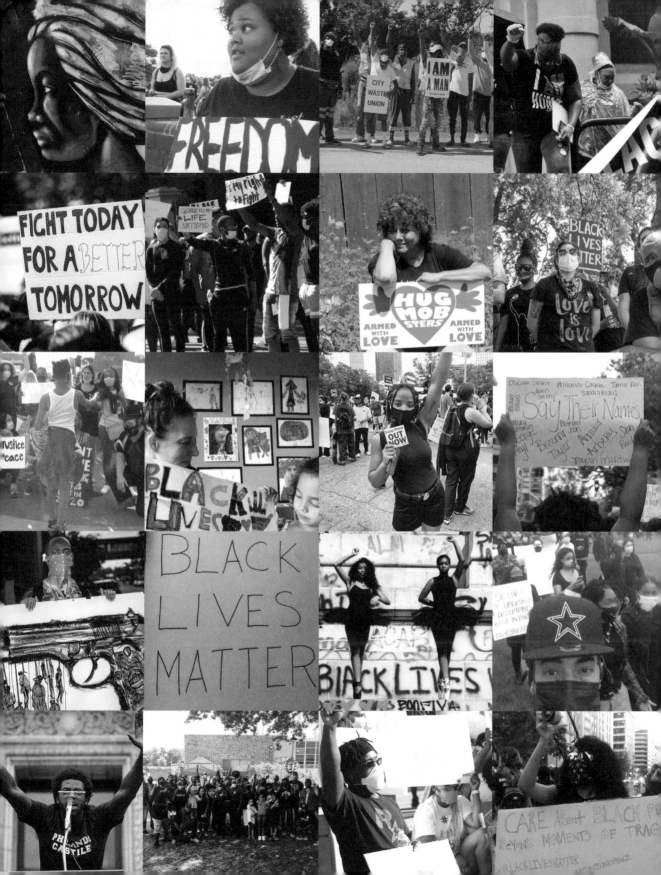

"**I NEVER EXPECTED** to see the entire world show up in support and solidarity of the Black Lives Matter movement. There's been so much repression and oppression that hopefully, from this, there's going to be some tangible, positive change in the hearts and the minds of our white community here in the United States. To not only show up in solidarity for the black community, for us to be seen as equals and to be treated equally and fairly, but to start dismantling racism within their own communities and to talk about systemic racism in the white community."

Jo-Jo J.

Yoga Instructor

NASHVILLE, TN
03 AUG 2020

Image by Tasha A. F. Lemley

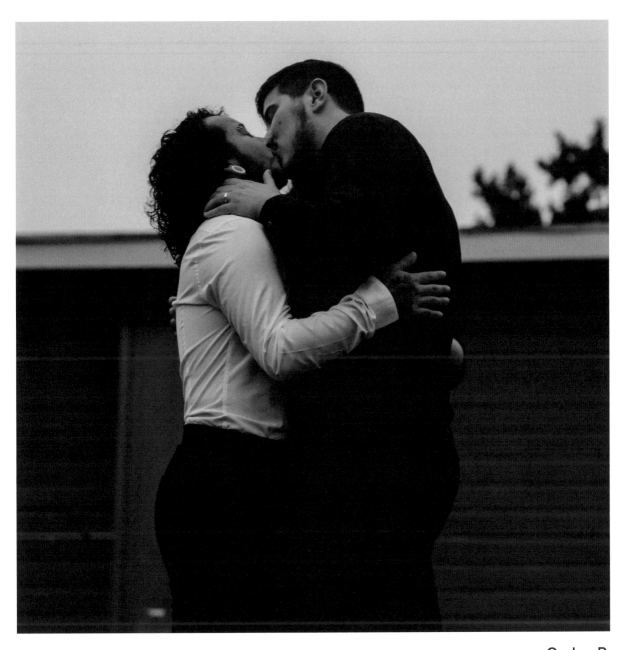

"**I WAS RAISED TO BELIEVE** that marriage is between a man and a woman, and people of the same race. If you would have told me at 12 that I would be married to a man, who is also Hispanic, I wouldn't have believed you. Growing up I struggled to accept my own sexuality and gender identity. I was raised in a Southern Baptist conservative home. I knew as early as 4 that I was meant to be a man. By the time I was 14 I also knew I was bisexual. My coming out was never easy, and I still have struggles with my family. However, I have no doubt in my mind that I married the love of my life. (We met on Facebook Dating of all places.)"

Cadyn R.

Age 25 / Retail / LubbockPride

AMARILLO, TX
27 JUN 2020

"**I STAND FOR** all of the people that were made to believe they weren't good enough."

Malchus C.

Age 25 / Student

NORTH HOLLYWOOD, CA
14 NOV 2020

"**I STAND FOR** freedom and independent living for Americans with a background of mental illness . . . Perhaps standing up proud and tall is hard for me—but setting a good example for youth is my deepest commitment."

Anonymous

ROCHESTER, NY
16 OCT 2020

"**LOOKING AHEAD, I** would like to see a USA that recognizes . . . that people with disabilities ARE people, first. I would like our facilities, roadways, places of employment, etc., to be 'handicapped friendly,' not just 'handicapped accessible' . . . People with disabilities are the largest minority group in the United States, the only group anyone can join at any time . . . we are just like you. Talk with us."

Carol J.

Age 61 / Librarian

ALBANY, NY
20 NOV 2020

"I was raised to believe a lot of things that I had to unteach myself. That's just the way it is."

Anonymous

BRONX, NY
23 FEB 2020

"**I WAS RAISED TO BELIEVE** that I am a citizen of the world and need to value every person in every nation and each person deserves my respect. I had a British Father, an American (USA) Mother, and a Burmese (Karen tribe) Nanny who was my 'other' Mother. I was raised in Burma, (Myanmar), Pakistan, India, and England . . . When I witness prejudice and discrimination, I think of my Burmese Mother and all those friends in all those countries where I lived, and I feel sad for them, and wish others personally knew and valued all people as I have tried to do."

Vivian F.

Age 70 / Retired Psychotherapist

HOMER, AK
24 NOV 2020

"YOU DON'T KNOW WHAT IT'S LIKE TO be autistic. In my world, other people are a mystery. I can never tell when people are telling the truth about how they feel or what they think, and everyone seems to follow some sort of ever-changing set of social rules I've never learned. It's like being in a foreign country all the time; I never know the native language or customs. No one seems to understand—I want to be accepted too. I am also human—not more than, not less than."

E. F.
Age 20 / Student
LUBBOCK, TX
26 AUG 2020

"YOU DON'T KNOW WHAT IT'S LIKE TO sleep on the streets and not know where your next meal is going to come from."

Wayne H.

Age 56 / Prep Cook / U.S. Navy

PORTLAND, OR
04 DEC 2019

"**I STAND FOR** women's rights! I am a baby-boomer, raised in a middle class family in the 1950's with 2 brothers, but my options as a girl were limited because of my sex. Expectations as a girl were far lower than for my brothers and options for career choices were limited. I went into nursing and forged a career after 10 years in a CCU and went back to school in my 40's and became a Nurse Practitioner . . . always obstacles as a girl, limitations to acceptance because I was a girl. Always a battle to prove that I have a brain as good as any male. I believe that my generation of women even now in our retirement have lower expectations for ourselves because we were taught to believe we were not as smart as our brothers."

Carol M.

Age 74 / Retired Nurse Practitioner

ELLSWORTH, ME
21 DEC 2020

PBS AMERICAN PORTRAIT : EQUALITY

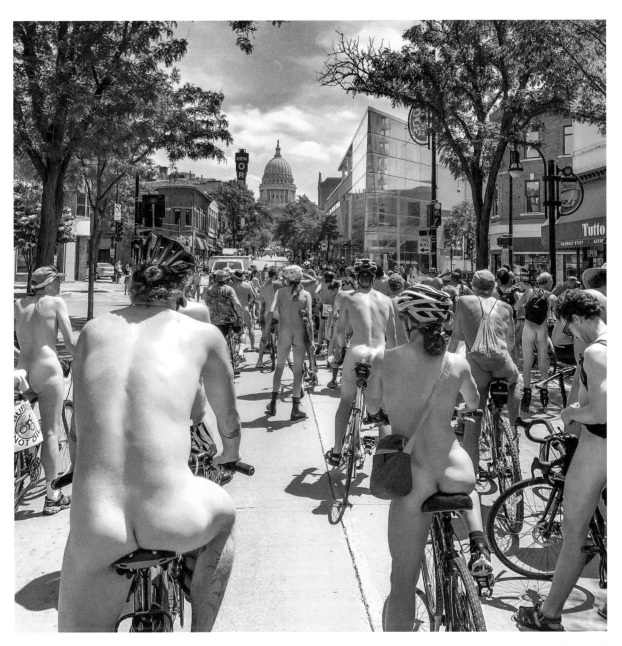

"I TOOK A RISK WHEN I joined the World Naked Bike Ride Madison, Wisconsin, for the first time last year . . . When we remove our clothes in non-sexual social situations, we often find that we have more in common with each other than share differences."

Chris K.

(WNBR) World Naked Bike Ride
Madison, Wisconsin

DE PERE, WI
07 MAR 2020

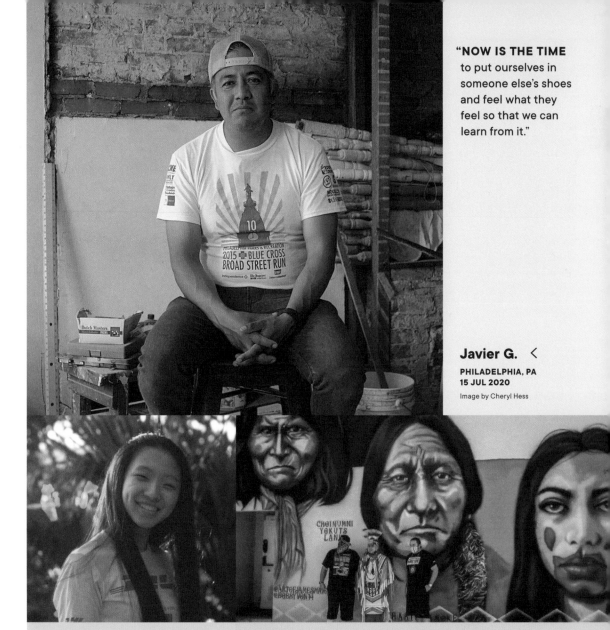

"NOW IS THE TIME to put ourselves in someone else's shoes and feel what they feel so that we can learn from it."

Javier G. ‹

PHILADELPHIA, PA
15 JUL 2020

Image by Cheryl Hess

"I STAND FOR . . . A step into my computer science class heralds a group of males who huddle in circles to play Minecraft. I dream of changing the preconceived notions of the STEM field so STEM is more inclusive."

Vivian W. ⌃

YORBA LINDA, CA
19 JAN 2021

"A DAY'S WORK IS . . . I use my art to highlight Indigenous history that's not taught in schools . . . I started to curate my own art exhibit so that Native American artists and myself can tell the correct story of our art and our culture."

Bobby M. ⌃

FRESNO, CA
20 AUG 2020

"**I WAS RAISED TO BELIEVE** that people are people. Most people are kind, most people want to be treated nicely. It's not hard."

Pat H. ∧
NEWPORT, RI
25 MAR 2020

Image by Giuliana Guarino

"**MY GREATEST CHALLENGE IS** . . . As a female, you have to go in there and show that you're the boss . . . You've got to have a tough hide and a tender heart."

Sally G. ∧
CRYSTAL SPRINGS, MS
13 AUG 2020

Image by R.D. & Ashley Chisholm

"**AT THIS POINT IN MY LIFE** the world has become more accessible through technology and interpreters. This gives me hope and change is for the better . . . Back in the day . . . there weren't accommodations for the deaf, and we became very frustrated . . . Today, you see more and more interpreters during live streaming, on Zoom, also YouTube. You also see more and more closed captioning now."

Shayinnia M. ‹
SILVER SPRING, MD
06 AUG 2020

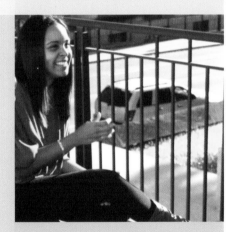

"**MOST DAYS I FEEL** like the world economic systems would look different if we leveled the playing field."

Nubian S. ∧
CORDOVA, TN
04 FEB 2020

"I was raised to believe that love was only for a man and a woman. Turns out it was wrong and God still loves me."

Anonymous
CARLSBAD, CA
03 APR 2020

"I WAS RAISED TO BELIEVE . . . I was born in 1930, but I didn't, until recently, realize how privileged I was to be a white woman in this society. It's only recently that I've understood how much injustice there is in the world and how I need to do something about it."

Barbara R.

Age 90

COOKEVILLE, TN
24 DEC 2020

"NOW IS THE TIME to express myself and tell my story my name is Sarah Luiz I'm a world-famous post-op transgender woman I became world famous suing my insurance company in 1989 for my sex change operation from there I was led all around the worldwide media because I talked about my life oh my gosh a transgender woman has a life that's right no one was going to put me back in the closet no one was going to beat up spit on me throw me down flights of stairs put my head down toilets treat me like a human garbage can any longer now 33 years later . . . I'm working on my third book, about to launch my second book who's having the last laugh now."

Sarah L.

Age 54 / Writer / Interim Inc.

SALINAS, CA
06 JUN 2020

"MY AMERICAN DREAM is to become a barista. I am 23 years old and have Down syndrome. My dream job has not been easy. While out of school and looking for jobs, many doors were closed. I am excited that a coffee shop in my community will be opening soon and will be employing people like me, with disabilities. I can finally start my dream job . . ."

J. B.

Age 23 / Work as a Salon Assistant at My Hair Salon / Future Employer Gerry's Cafe, Theater Group Edge of Orion, Support Group UPS for Downs

ARLINGTON HEIGHTS, IL
23 JUL 2020

"WHAT KEEPS ME UP AT NIGHT IS the state of our criminal justice system. Until 1999, I didn't even know anyone who was incarcerated. Now, not only do I know someone, I have been his advocate for 20 years, fighting for his freedom from a wrongful conviction. There is an estimated 2–5% wrongful conviction rate in the United States."

Sue T.

AKRON, OH
10 APR 2020

"THE PEOPLE I RELATE TO ARE people who pretty much rock the golden rule. I just wanna treat you like you wanna be treated. I feel like I can almost relate to anybody if I can get in a room with and converse with them and find out what they like and what they may not like."

Vinnie R.

Barrel Stove Combo

WHITEFISH, MT
14 JUL 2020

"You've got to jump off cliffs all the time and build your wings on the way down."

—Ray Bradbury

"I took a risk when I rock climbed and circumnavigated the rim of Yosemite Valley to paint the landscape. With my sketchbook, I would often peek over the edge, sometimes clinging to a tree or shrub or, as shown here at Taft Point, simply trusting my feet. A slightly risky practice perhaps, but a fair trade for the best views as well as one of the best experiences I've had."

Keith H.
Age 67 / Artist
SAN FRANCISCO, CA
09 DEC 2019

"I was raised to believe in integrity, knowledge, being humble, giving everything your best. It's the traits passed down to me from my parents that have made me who I am today. I was also raised to take chances and go for it!"

Chris C.

Age 33 / Mortgage Broker, Entrepreneur
SAN DIEGO, CA
15 JAN 2020

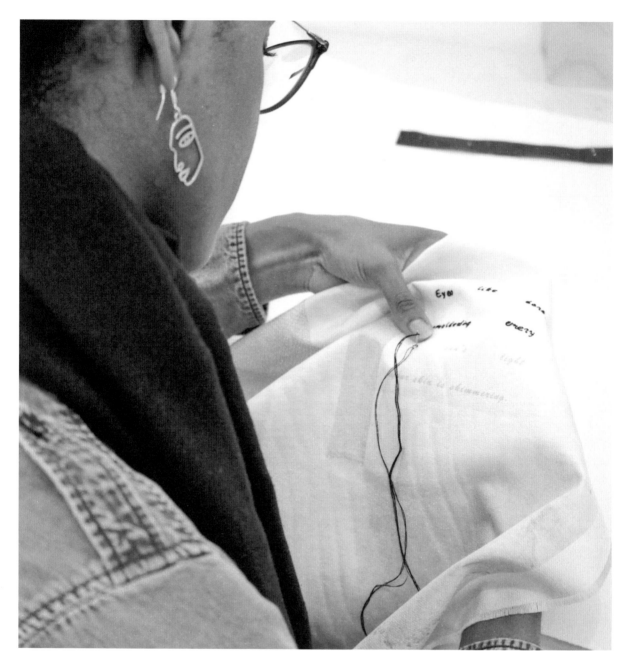

"**I TOOK A RISK WHEN** right after undergrad I bought a ticket with the little money I had in my bank account—a one way ticket to New York City because I felt like that was where God was telling me to go. I didn't have a plan and didn't have a job lined up. I knew one person in the city, didn't have a place to stay exactly, but I bought the ticket, went downstairs and told my mom that I was moving to New York City. She asked, 'When?' I said, 'In a month.' She said, 'Well if you want to go, I guess now is the time to go.'"

Dea J.

Artist

PASADENA, CA
12 MAR 2020

Image by Princess Garrett

"I took a risk when I ran away from my abusive home at 15 and asked to be put into foster care.

Grown up in the backseat of a car, I needed a safe place to live, the chance to go to school, the opportunity to learn and to grow into my own dreams. So, I ran. Ran away from all I had ever known. I took a risk I'd be taken care of."

Chris R.

Age 68 / Writer
LOS ANGELES, CA
20 NOV 2020

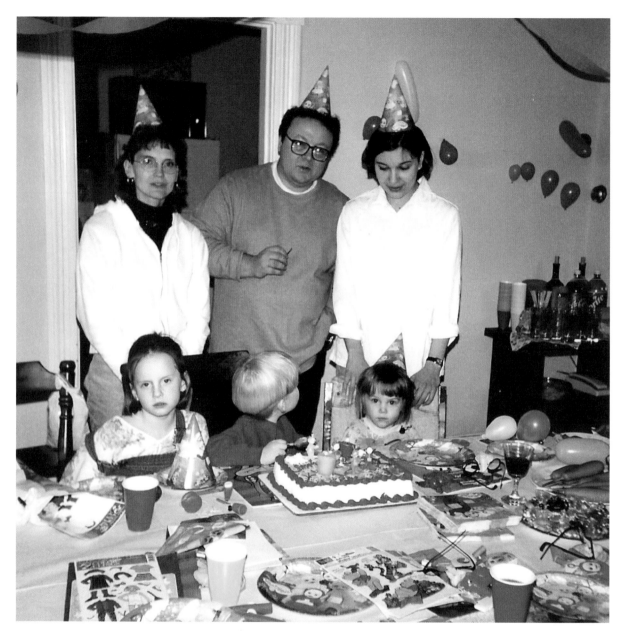

"MY AMERICAN STORY STARTED WHEN my Papa won the Green Card lottery. My Siberian family couldn't believe that we were going to live in America, a place where everyone wore blue jeans and where any dream is possible. My parents packed two suitcases, said goodbye to their jobs, their Great Dane, their friends and moved to St. Louis, Missouri. My Russian parents who spoke little English, adapted as best as they could to American life, throwing me TV themed birthday parties with sheet cakes and corn dogs, eating cereal for breakfast and making new American friends. I always wonder who I would be if we still lived in Siberia and if we never won a Green Card. I am so thankful for this opportunity and for the risk my parents took."

Eve N.
Age 24 / Designer
NEW YORK, NY
18 JAN 2021

"I TOOK A RISK WHEN I sent my application to Ringling Bros. Barnum and Bailey's Clown College in 1982. I was lucky enough to get accepted. I come from a small town in rural Minnesota. No clowns in my family. It was a wild and crazy dream I didn't expect to come true, but it did. I was offered a contract and performed as a circus clown, lived on a train and traveled the USA for three years. It totally changed the trajectory of my life . . . I have never worked as hard, laughed as hard, experienced America in such a way . . . I have traveled the country and even overseas teaching clowning, performing, selling costumes but most of all sharing the joy of the clown."

Tricia M.

Age 59 / Clown, Educator,
Costume Designer /
Mooseburger Clown Arts Education

MAPLE LAKE, MN
18 JAN 2021

"I TOOK A RISK WHEN in 1988 against the advice of my GP and spinal surgeon, I carried my daughter to full term. I was told by doing so I could become paralyzed, because of my bad spine. So my only option was to abort. I politely declined, I wanted my baby. I had one spinal surgery already (they told me I was about two weeks to one month pregnant when I had that surgery) and throughout the years I had 4 more; spinal fusion with fixation (screws & rods), lumbar laminectomy, spinal stimulator & removal of stimulator. My daughter is a healthy and hardworking single mom to my grandbaby."

Brandy R.
Age 54 / Retired Pharmacy Technician
CARSON, CA
08 OCT 2020

"**I TOOK A RISK WHEN** I searched for my biological mother . . . I had just turned 30 and I was getting ready to go on a trip to Korea. And I thought this seems like as good of a time as any to search for my biological mother . . . When people take risks, I think they don't really always realize that it is a risk. And so I didn't realize at the time how vulnerable it really was, because I don't think I really could imagine what the worst possible scenario was . . . she doesn't want connection. And so of course that was what happened. That was really scary and really horrible and hard, but there's something really liberating about closing the door on some questions that I had my whole life and freeing myself up for focusing on my chosen family and the family I have around me."

Caitlin B.

Age 33 / Senior Social Innovation
Specialist / Design Impact

**CINCINNATI, OH
09 OCT 2020**

Image by Biz Young and
Kearston Hawkins-Johnson

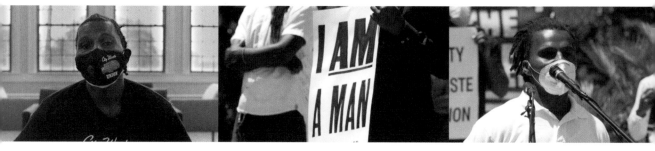

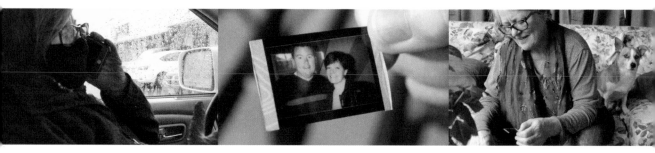

"**I TOOK A RISK WHEN** I decided to strike, not knowing how I was gonna feed my seven children."
HAROLD P. — NEW ORLEANS, LA

"**I TOOK A RISK WHEN** I decided to search for my son whom I placed for adoption (closed) when I was a teenager in 1972. I went looking for him when he was 25 . . ." **NANCY B. — CHICAGO, IL**

"**I TOOK A RISK WHEN** I decided to convert into the 'Most Dangerous Religion.'" **LEAUNA P. — NORTH STREET, MI**

"**I TOOK A RISK WHEN** I went against everything I was ever taught, and raised to believe in. I did not develop the traits of toxic masculinity, left the church, and I dropped out of college my first semester and pursued my music, which was one of the best decisions I ever could have made." **N3PTUNE — DENVER, CO**

PBS AMERICAN PORTRAIT : RISK

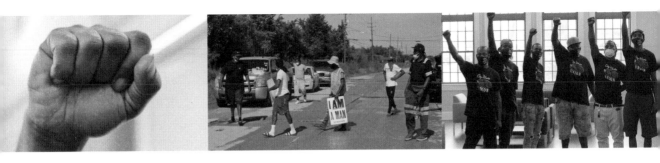

Images by Jessica Vitkin

Images by Kristen Williams

"I TOOK A RISK WHEN I ran to the mountains to quit being an LDS missionary and find my own meaning to live. When I was 21 years old I made the hard decision to leave my family's expectations as a missionary. I ran from the police and the Mormon church in order to live in the wild freely. I lived out in the California wilderness for a week and a half and had hiked around 200 miles before I got very sick from what I suspect was arsenic poisoning. I returned home to Missouri and saved up so I could return to the woods. After over 8000 miles of hiking, fighting off a grizzly bear, dodging fires, making it through California during a record snow year, and doing what others told me wasn't possible, I have found my place in life."

Wesley T. ‹
BLUE SPRINGS, MO
13 DEC 2020

"I TOOK A RISK WHEN I decided to build my own airplane in my garage. After 6 yrs of building, I did my best to see that no nuts or bolts were missing, or wires crossed. When I woke to a sunny day with little wind, I knew it was time to try to fly . . . 300 flying hrs later, when I fly I'm still amazed I built this in my garage and the grin is still there."

Al G. ∧
NEWPORT, RI
30 JAN 2021

"MY PARENT(S) WANTED ME TO . . . A few years ago I was diagnosed with Epilepsy. It put a halt to a lot of my life plans, like my dream of traveling solo. Any sort of travel became extremely risky but I wasn't going to let it stop me from living my dreams, so with the dr.'s approval I booked a flight and off I went . . . the greatest risk I've taken to date."

Kristina T. ∧
BROOKLYN, NY
15 JAN 2021

"I TOOK A RISK WHEN I decided I wanted to dance. I had a common misconception that dance was only for girls since it is heavily dominated by women. It took me actually experiencing the act of dance to understand the universal meaning behind it. Anyone can dance no matter gender or race . . . The risk I took by choosing to dance connected me with the right people and ultimately was the best decision of my life because it showed me that my true passion is dance."

Kamani A. ‹

NEW CASTLE, DE
28 SEP 2020

"I TOOK A RISK WHEN I decided to pursue a graduate degree in disability studies here at the University of Toledo. Against the advice of mental health professionals at the time, who thought the rigors of university study would be too much for me, given my history of PTSD and major depression, I felt in my heart that it was the best way for me to move forward and recover my life."

Douglas K. ^

TOLEDO, OH
09 DEC 2019

"I TOOK A RISK WHEN I decided to go to therapy."

Christine H. ^

AUSTIN, TX
22 JAN 2021

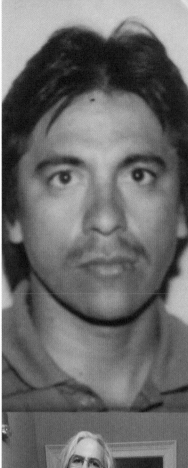

"I TOOK A RISK WHEN I dropped out of high school. By my freshman year, I was dragging myself to classes . . . US History portrayed Mexicans as villains and unworthy. So, when the principal gave me a choice to take my punishment for speaking Spanish or leave school, I walked away . . . Mother, aware of my fiasco at school, was compassionate and supportive . . . Eight months later, I was a high school graduate and a model student. I took a risk, and in the end, it all paid off."

Guadalupe C. ‹

PASADENA, TX
31 JAN 2021

"I TOOK A RISK WHEN I decided to be a mother at 18."

Alaneo A. ˄

MAKAWAO, HI
06 MAR 2020

Image by Alana Davis

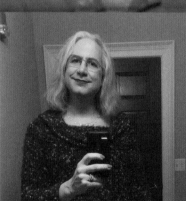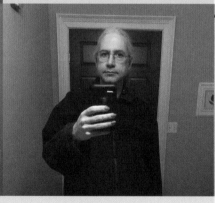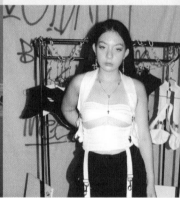

"I TOOK A RISK WHEN I came out to my wife and family. After not quite twenty years of marriage, four children, I finally could not resist any further and came out as transgender female. The number of leaps of faith that I have had to take is huge."

Serena J. ˄

BUFFALO GROVE, IL
06 JUN 2020

"I TOOK A RISK WHEN I stopped doubting myself and went towards what I truly desire and stopped listening to anybody but myself."

Leilani Z. ˄

MESQUITE, TX
22 OCT 2019

"I TOOK A RISK WHEN I flew to Oregon from Connecticut in July 2020 for my annual road trip with my 95 year-old Dad, while my 95 year-old Mom lay in hospice back home. The dilemma was that this might be the last time I'd see him, but if she died while I was away, I'd never forgive myself. Upon my return to Connecticut . . . after five days of warm family farewells, Mom died. I'll never know whether she was waiting for my return to leave her earthly bond. Dad died October 27th."

Judith S. ‹
MANCHESTER, CT
04 FEB 2021

"THE TRADITION I CARRY ON IS . . . I jumped in last minute to save one of the oldest community taverns in the United States when it was 3 days from closing back in 2009. I had no restaurant experience & had a full time job. After arriving in America at 10 years old from Jamaica, a community of people helped me. Jumping in to save one of America's gems was my way to give back to the country and my community."

Loycent G. ∧
WOODHAVEN, NY
15 NOV 2020

"I TOOK A RISK WHEN, as a pacifist, I made the agonizing decision to either dodge the draft or do my best in the US Army."

Andrew D. ∧
FREMONT, CA
12 OCT 2020

Image by Andrew de Lory

"I TOOK A RISK WHEN
I married the gringo who
crashed my birthday
party in 1981!"

Ruth Maria C.

CHARLOTTE, NC
19 DEC 2020

"I TOOK A RISK WHEN . . .
Three days into my trip
I met an attractive, warm
and funny Venezuelan who
spoke no more English than
I spoke Spanish and fell in
love at first sight.
I took a risk when I married
him two years later,
12 years after I had been
widowed by suicide. I took
a risk when we moved
together to Buenos Aires,
Argentina, a country neither
of us had visited, and
immersed myself in
a strange culture. I took
a risk when we sold
everything we owned
to travel the world . . .
43 countries and counting.
He took the greatest
risk of all: leaving behind
everything and everyone he
had ever known,
moving to the US for me
and becoming an
American citizen."

Simone C.

Age 59 / Program Manager /
Amazon

CHANDLER, AZ
24 DEC 2020

"I took a risk when I married an African American man in 1971."

Ellen M.

Age 73 / Judicial Educator (retired) /
Maryland State Courts, DC Courts, National
Association of State Judicial Educators

BALTIMORE, MD
10 JUL 2020

PBS AMERICAN PORTRAIT : RISK

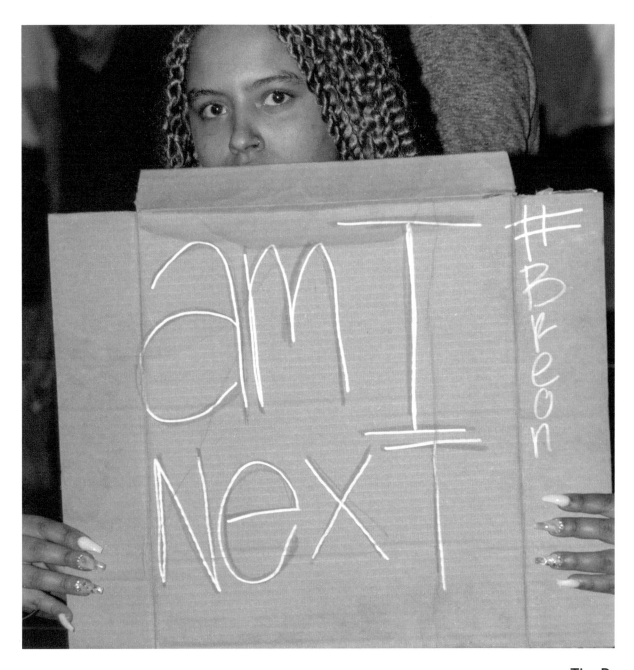

"**I TOOK A RISK WHEN** I walked into an emotionally charged crowd of demonstrators and decided to tell the truth. The truth has never been a problem for me, but the courage to tell it when nobody asked—that's where it really comes down to guts. Anybody can stand in a high place and photograph a crowd with a zoom lens, but on this day, I decided the truth was among the sweat and the chanting voices, the tear gas and the pepper bullets."

Tim D.
Age 43 / Photographer / Black Lives Matter
LOUISVILLE, KY
05 JUN 2020

"My American story started when I made the decision at 10 years old to reunite with my mother in the USA.

I was asked if I was ready to cross the river. I was not afraid. After I crossed, I changed into dry clothes behind a corner store. Fireworks were popping and lighting the night sky. It was on the 4th of July—America's Independence Day. I was being welcomed by the universe even though some people would like to think I should have done it 'the right way.'

Flor H.
HOUSTON, TX
10 FEB 2020

"**I NEVER EXPECTED** to end up in the USA. It was my last resort to escape the violence in my country and create a new, safe life. Growing up in Venezuela, one of my wildest dreams was to one day take pictures of the museums in Washington DC . . . Coming to America all by myself as an asylum seeker, the odds seemed to be against me, and still, I found myself not just visiting but working in the same museums I couldn't envision setting foot in. I keep finding and making ways of belonging, and though far from a perfect nation, if there's one thing that makes the United States of America special it's that nothing is impossible here."

Fabiola R.

Age 30 / Arts & Cultural Administrator

WASHINGTON, DC
08 JAN 2021

"**MY AMERICAN STORY STARTED WHEN** the Asian economy collapsed. I was young, I was ambitious. I was raising a young family—so I embarked in a very risky business adventure. Unfortunately, my business collapsed with the Asian economy, so I began looking into how I could sustain my family in the United States."

Daniel R.

Age 51 / Pastor / Maui Philippine
Baptist Church

KAHULUI, HI
06 DEC 2019

"**THE TRADITION I CARRY ON IS** making voices heard. My grandfather was a prominent film director in Vietnam. When the communist party took over during the war, they deemed my grandfather's work to be anti-communist propaganda and captured him as a prisoner of war. Any evidence could have been used to capture more innocent lives so my grandmother set my grandfather's old films aflame. Today, I am a medical student in the United States. I look up to my grandfather a great deal. He knew he was risking his life to make a stand the way that he did."

Chandat P.

PERKASIE, PA
02 JAN 2021

"**MOST DAYS I FEEL** conflicted because my parents came over to America when I was young. They worked really hard and didn't focus on themselves. They focused on giving me and my siblings the best life. My parents didn't care what I do, they just wanted me to support myself and be happy. At the same time, what I want to do, I'm not sure I can be able to support myself and I don't want to follow what my siblings do, which is engineering. I don't want to regret everyday that I'm doing something practical instead of doing something that I like."

Mai T.

Student

SHREVEPORT, LA
10 MAY 2020

STRU

"Success is never so interesting as struggle."

—Willa Cather

GGLE

"You don't know what it's like, or very few people know the feeling of walking away from everything you know and stepping into what seems like an alternate dimension; it is a dimension fueled by focused hate, anger, discipline, rigid adherence to standards, and it changes who you are forever."

Adam H.
Age 30 / U.S. Marine / U.S. Military
LAUREL, MD
03 DEC 2019

"YOU DON'T KNOW WHAT IT'S LIKE TO lose all of your mobility in your twenties. To constantly wonder if there's anything that can be done, or if you need to just give up, stop trying to get better, and move on with your life. To always have the awareness in the back of your mind that this will probably continue to get worse, and that you should feel lucky to have the amount of mobility that you still have. To have absolutely no idea how to make space for the grief, or if that's even possible."

Emily A.
CINCINNATI, OH
02 OCT 2020

Image by Biz Young

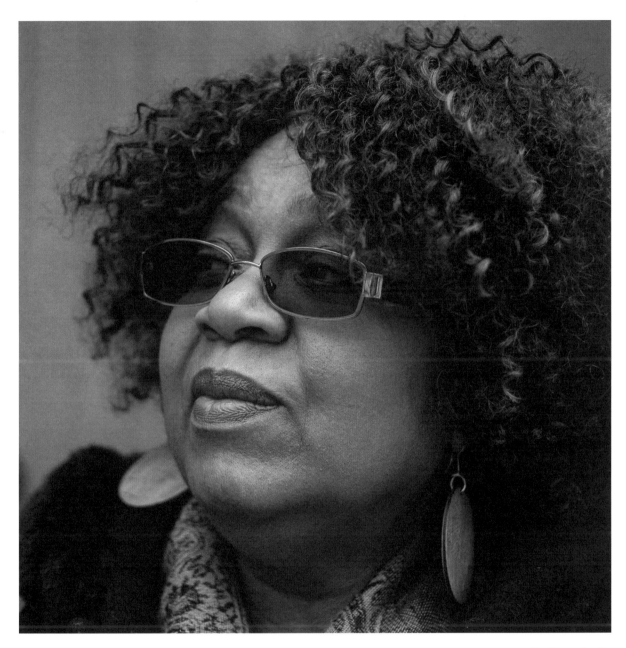

"I WAS RAISED TO BELIEVE that if I did everything that society told me to do, like work hard, get an education, and obey the law, that certain things would not happen to me. But I've come to realize that things do happen, and often those things are out of my control. I did what society said I was supposed to do, and I still experienced homelessness."

DeBorah G.

Age 50 / University Professor

WILMINGTON, DE
10 JAN 2020

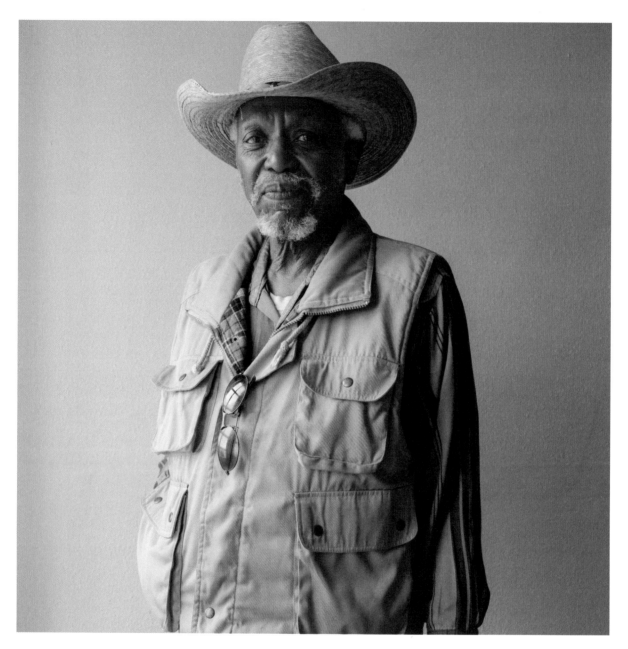

"**MY GREATEST CHALLENGE IS** maintaining my mentality and not going stir crazy during this whole mess. I am waiting for the libraries to open back up. I've had a book for 3 months. I am waiting to check it back in."

Cowboy
Age 72
TACOMA, WA
31 AUG 2020

Image by Stephanie Severance

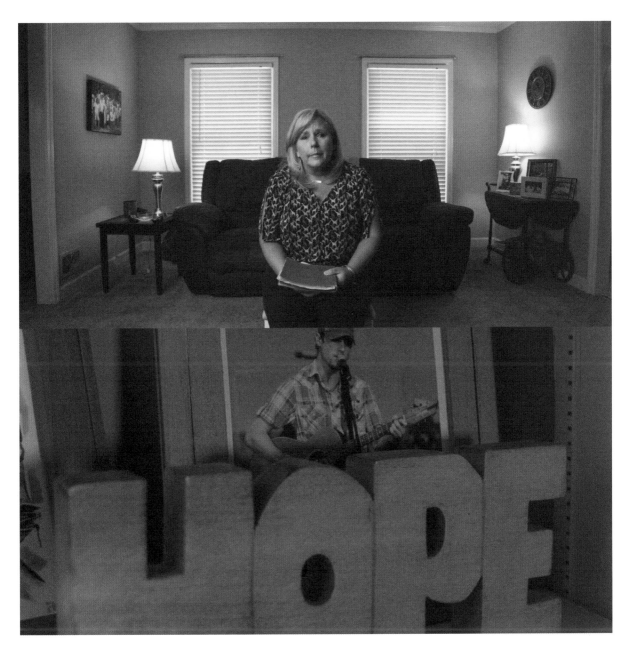

"**WHAT KEEPS ME UP AT NIGHT IS** the number 48,344. That's how many people died in 2018 by suicide. On September 6th, 2018, my son became one of those."

Terry L.
AUGUSTA, GA
04 AUG 2020

Images by Justin Wheelon

"MY GREATEST CHALLENGE IS being a stay at home, self employed, single mom. The responsibilities of providing myself with employment and then doing the work all while raising a toddler by myself have been a challenge. But it's worth it. It's more than worth it. My biggest challenge is also living my dream. I'm so grateful I can spend every day with my girl."

Hannah T.

Age 33 / Designer

SHORTSVILLE, NY
19 FEB 2020

"**I NEVER EXPECTED** to be in the position that I am in. Because of the way my life started I was not sure that I would even live as long as I have. I was born with Tourette's, OCD, and ADHD. I developed PTSD before I was even sixteen because my father was a violent alcoholic, and my mother was an addict. My brother was both. But somehow I survived."

Markus H.

Age 70 / CEO /
The Tourettic Bully Proofer LLC

SACHSE, TX
09 JUL 2020

"MY GREATEST CHALLENGE IS struggling to find myself while being told that my true self isn't accepted or okay."

Peyton S.

Age 15 / Student

**NORTH RICHLAND HILLS, TX
16 SEP 2020**

"YOU DON'T KNOW WHAT IT'S LIKE TO live until you are given an amount of time you have left on earth. I was diagnosed with brain cancer at age 12. I am now 18 and this is my third round of chemo in the past few years. In October, I was given 1 more year. I can't even go out and do the things I wish I could due to COVID-19. I feel like I've regretted my whole life and wasted it. I never found love, real friends, got my diploma, had kids or got married. I never worked my dream career. Everything is just taken away from me through this illness."

Anonymous

**OMAHA, NE
09 DEC 2020**

"WHAT KEEPS ME UP AT NIGHT IS that I'm not living. I know that I am waking up every day, and I am breathing, but I am not really living."

Laur O.

Age 41

**ROCHESTER, NY
05 JAN 2021**

"My greatest challenge is knowing and accepting I will go blind.

I have a rare condition that will take if not all then most of my vision. I'm afraid that I will be part of the group that loses all of my vision and I won't remember what my family looks like anymore."

Anonymous

**ROSEMEAD, CA
23 SEP 2020**

"MY GREATEST CHALLENGE IS learning how to construct a meaningful life now that my son with special needs has died. He WAS my life and without him, who am I?"

Ann A.

Age 60 / Retired Teacher

WINNECONNE, WI
29 NOV 2020

"You don't know what it's like to get a FaceTime call from a doctor on the other side of the country, holding up an iPad so you can see your father— unconscious, on a ventilator— for the last time. Or to get another FaceTime call from a family member, holding a phone up at his graveside, where no funeral could take place. Or to run a 3 hour memorial on Zoom for over a hundred people to share stories about him, while your mother, also fighting the virus, tried to stay conscious and listen in."

J. B.

LOS ANGELES, CA
05 MAY 2020

"**MY GREATEST CHALLENGE IS** my struggle with anxiety and depression, but mostly depression. I can get a lot done and do some great things but first I have to work hard to push myself through this sort of barrier of negativity and feeling hopeless."

J. O.
Age 30 / Library Assistant
WARRENVILLE, IL
12 DEC 2019

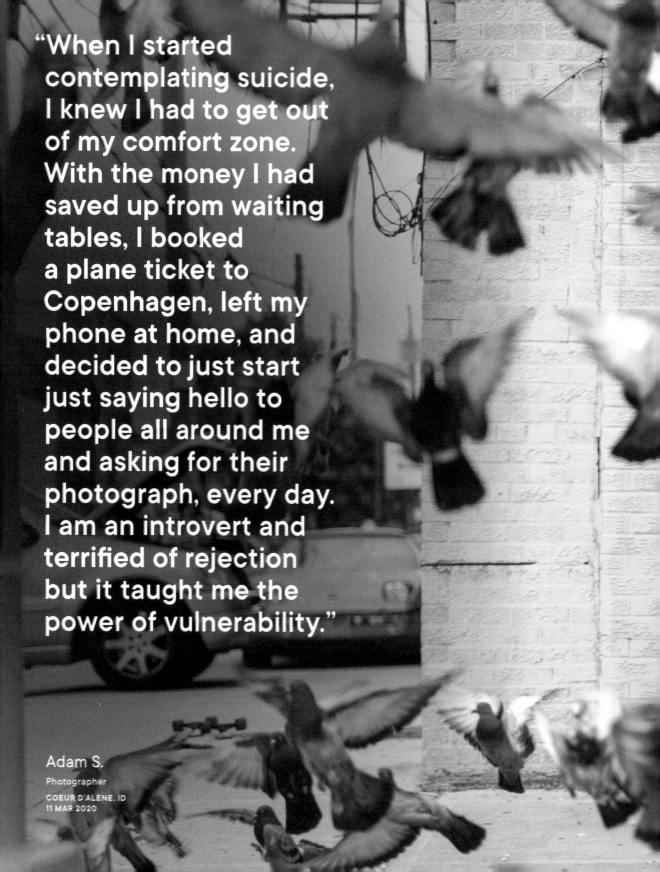

"When I started contemplating suicide, I knew I had to get out of my comfort zone. With the money I had saved up from waiting tables, I booked a plane ticket to Copenhagen, left my phone at home, and decided to just start just saying hello to people all around me and asking for their photograph, every day. I am an introvert and terrified of rejection but it taught me the power of vulnerability."

Adam S.
Photographer
COEUR D'ALENE, ID
11 MAR 2020

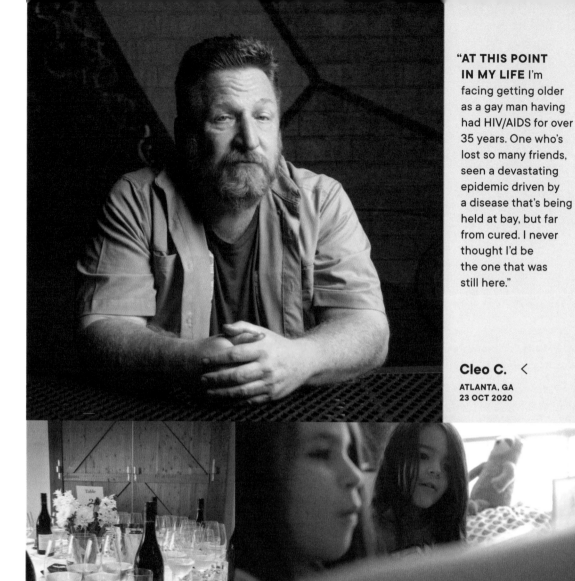

"AT THIS POINT IN MY LIFE I'm facing getting older as a gay man having had HIV/AIDS for over 35 years. One who's lost so many friends, seen a devastating epidemic driven by a disease that's being held at bay, but far from cured. I never thought I'd be the one that was still here."

Cleo C. ‹
ATLANTA, GA
23 OCT 2020

"TO ME, WORK MEANS going into a battlefield. As a waitress during a pandemic, I never know if I am safe."

Anonymous ^
INDIANAPOLIS, IN
07 AUG 2020

"I NEVER EXPECTED to have to juggle working at home full time while also wrestling with how to explain a global pandemic to my daughters. Although Olivia is only 6 years old and Stella is only 4 years old, I was surprised to see how much they comprehended at a time when even as an adult I'm struggling to grasp what is happening."

Jon C. ^
PHILADELPHIA, PA
18 MAR 2020

"FAMILY LOOKS LIKE protecting each other from germs. Stroke survivor protects wife, and wife protects stroke survivor."

Y. T. `<`

SEYMOUR, TN
27 JUL 2020

"YOU DON'T KNOW WHAT IT'S LIKE TO be a drag queen in high school. It's actually a lot more difficult than you think. It is very hard to walk through the hallways afraid of getting beaten up. It's very hard to walk into a classroom and everyone moves away from you because you're different."

Dakota R. `<`

RONKONKOMA, NY
23 JUN 2020

"I NEVER EXPECTED to bury my Son-Sam! Just 5 months after my father passed and 2 years after losing my Brother, I never thought someone would murder my Oldest Son."

Arnetta B. `^`

MARYVILLE, IL
13 OCT 2020

"At this point
in my life,
I never imagined
I'd be sitting
in quarantine,
unemployed,
and wondering
what's next . . ."

Lilia I.

Stage Manager and Geography /
Environmental Studies Lecturer

SANTA ANA, CA
19 JUL 2020

"WHAT KEEPS ME UP AT NIGHT IS being trapped in the system, having to fight for the money that we worked for. Being unemployed and having to call and check in just to see if we're getting our money this week. Having to fight for it."

Joe N.

Age 31 / Unemployed / LGBTQ community

ALBUQUERQUE, NM
27 OCT 2020

"MY LIFE RIGHT NOW . . . My dreams at night are filled with the end of my career in 2020 and hopes of future work. I wake before dawn with a flood of thoughts and emotions. I miss the inspiration and purpose work gave me. These mornings, there's a repetitive feeling reminiscent of the film *Groundhog Day* . . . It's as if the social distancing that is supposed to save my life, and others, is dampening my spirit. I'm fearful my best is behind me."

Brian H.

SAN DIEGO, CA
12 JAN 2021

"AT THIS POINT IN MY LIFE . . . Before the pandemic I was working for three different jobs making excellent money but now I'm at nothing barely making it thru the weeks but I was always brought up to keep a hustle . . . that's my side of the AMERICAN DREAM. Hope all is well and staying safe."

Juan C.

Age 27 / Young Legends / Capital workforce partner / Our Piece Of The Pie

HARTFORD, CT
18 SEP 2020

"I NEVER EXPECTED . . . I was fired before COVID, and I've been trying to find a job since . . . I just never thought I'd be in this position where I'm not contributing to my community, to my household . . . It's really hard on my mental state. It's really taken a toll on my confidence."

Anonymous

HIGHLAND MILLS, NY
30 SEP 2020

"MY GREATEST CHALLENGE IS being a 43 year old widowed mother of two. My oldest son is 19 and Autistic, going to college in August, my other is 12. As if all that was not challenging, try getting a job at my age, without a college degree. It is almost next to impossible . . . in this millennial world where connections weigh more than a resume."

Marilyn S.

Age 43 / Job Seeker / Member of the Coast Guard Auxiliary and Volunteer Translator for Translators Without Borders

CAROLINA, PR
14 FEB 2020

"I NEVER EXPECTED . . . I was fired for insubordination . . . I was told by unemployment . . . I was not eligible because I was not affected by the virus . . . But I definitely was affected by the virus. Do you know how hard it is to get a job in a smaller town in the middle of a pandemic?"

Nicole O.

Age 42 / Medical Billing

RUSSELLVILLE, AR
20 OCT 2020

OPPOR

"If opportunity doesn't knock, build a door."

—Milton Berle

UNITY

"The problem I had when I came to this town is I was illiterate. I did not know what I was doing, but I took it upon myself to get educated so that I get a job."

Olabisi O.

Nurse

MESQUITE, TX
12 APR 2020

"**MY AMERICAN STORY STARTED WHEN** my mother, Amelia, met my father, Jose, in the Philippines. When my brothers and I were just kids, in the Philippines, we moved to the United States in 1970. Soon after my younger twin sisters were born in the States. We jokingly say that they're the only ones in our family that could run for president.

We were taught that we were born Filipinos but we were raised Americans. We had an obligation to give back to the country that took care of us and raised us. My mother got her Master's degree in Social Work and became a therapist, now retired. My 2 older brothers and I became 1st generation law enforcement officers. We all grew up to become a very intricate part of the American tapestry."

Jose A.
CHARLOTTE, NC
05 APR 2020

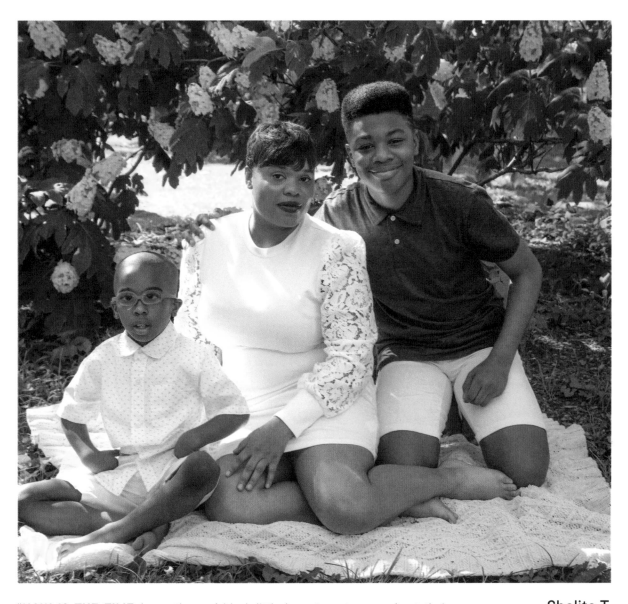

"**NOW IS THE TIME** for mothers of black little boys to not worry about their sons' future. Our boys are born with a target on their back simply because of the color of their skin. At a certain point in their young lives, black mothers have rough conversations about what they will possibly face during their life. Each day I wake up to see black men killed because of their skin color. I always wonder will my little boys be next? My goal is to raise my boys to be successful, productive, and proud black men. Men that will protect and fight for their beliefs and help others. I wonder will my children have the opportunity to let their light shine. I don't believe in living in fear but I'm scared. I'm scared for my boys . . ."

Shalita T.

Age 35 / Advocate

HENDERSONVILLE, TN
14 JUN 2020

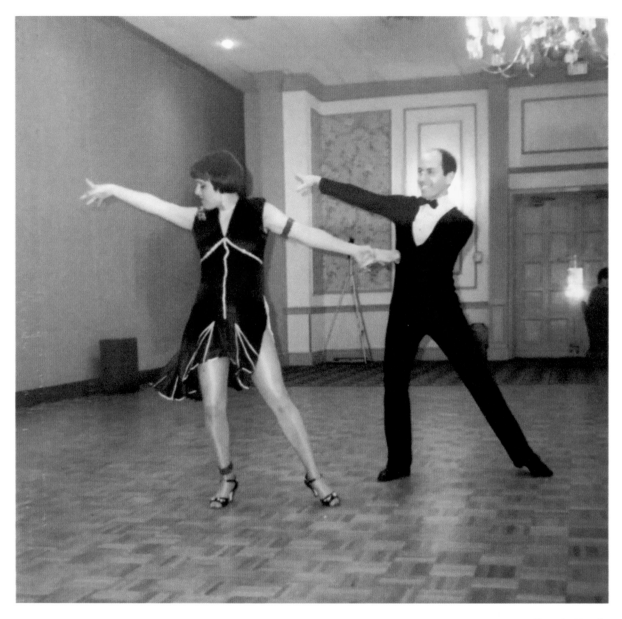

"MY AMERICAN DREAM is to become a ballroom dance instructor . . . I went to law school. I didn't want to go to law school, but I went to law school. I did graduate in the top 10% of my class. I was at GW . . . I took a lot of dance classes at GW because they were free . . . I remember crying on the beach and saying it to my father, 'I don't want to be a lawyer. I don't want to do this,' and he said, 'You can't be a quitter. You got to finish law school. I don't care if you're never a lawyer, but you can't quit,' . . . I said, 'I think I want to be a ballroom dance teacher,' and I looked online and I found this program in Las Cruces, New Mexico, which will be kind of like a crash course in ballroom dancing . . . It is not a high status job like I have had, but at this point in my life, I don't care what people think anymore. It's for my heart. It's for my soul."

Danielle S.

Age 60 / Retired Attorney /
Budding Ballroom Dance Teacher

**BERKELEY, CA
05 JAN 2021**

PBS AMERICAN PORTRAIT : OPPORTUNITY

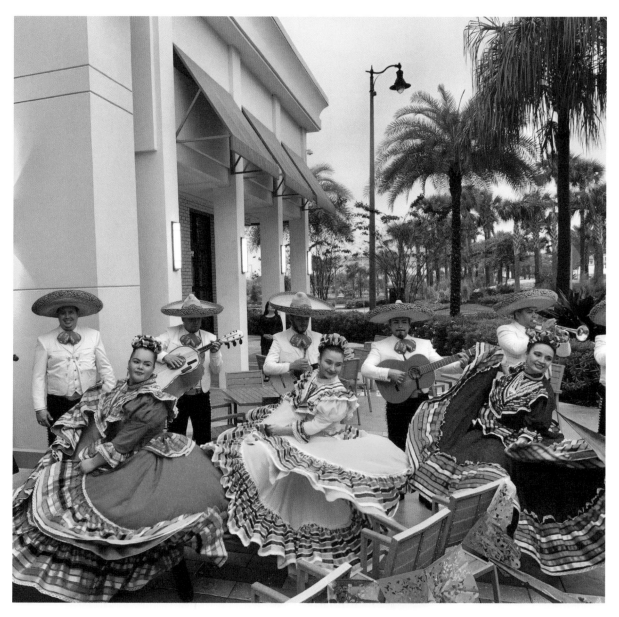

"**MY AMERICAN STORY STARTED WHEN** 20 years ago I came to USA as a Mexican immigrant to join Felix, my husband who I met in Mexico when I was 16. He is my sweetheart, a great chef and a role model to our daughters. This great country has allowed me to continue to practice my profession as a Veterinarian Pathologist which is the best career in the world; I am able to detect deadly diseases threatening our pets and livestock. Since a kid I learned Mexican Folkloric dance. Besides practicing my profession, I felt the need of passing the traditions of the Mexican Folklore to other cultures and generations to come especially to our daughters Mariana and Isabel. With that goal, I created Mexico Lindo Folkloric Ballet-Orlando and for the last 5 years the group has been spreading the joy of Mexico. I've fulfilled my dream."

Gizela M.

Age 50 / Veterinarian Pathologist /
Florida Department of Agriculture
and Consumer Services

KISSIMMEE, FL
02 AUG 2020

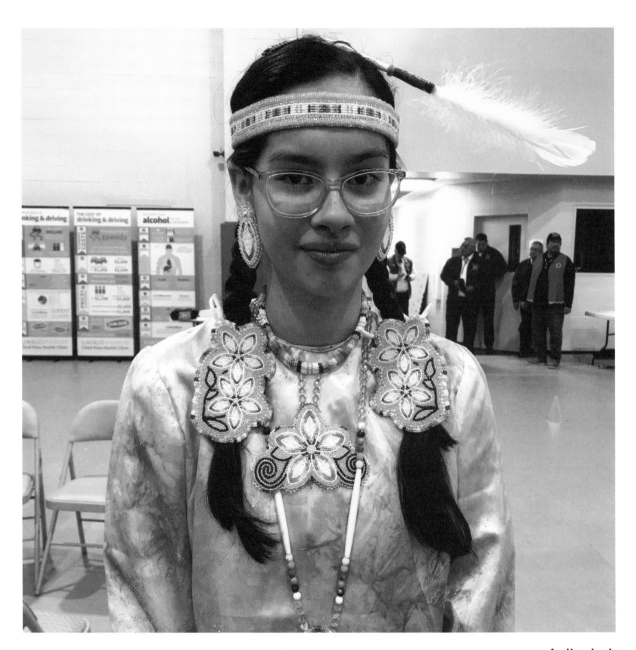

"**MY AMERICAN DREAM** is to continue to pursue my art and comedy. My name is Aaliyah and I'm 13 years old. I'm an enrolled tribal citizen of the Alabama-Coushatta Tribe of Texas. I enjoy sketch drawing and posting my comedy videos. I like making people laugh. I also enjoy dancing with other Indigenous people at Powwows!"

Aaliyah J.
Age 13 / Student /
Alabama-Coushatta Tribal Citizen

LIVINGSTON, TX
22 SEP 2020

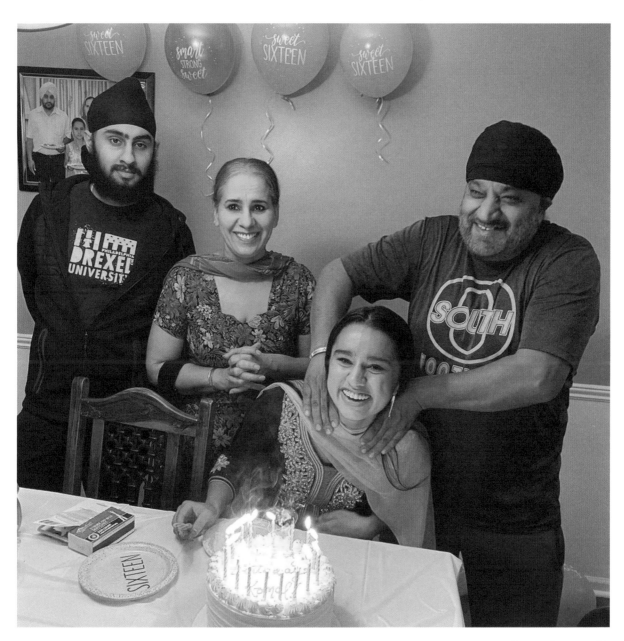

"YOU DON'T KNOW WHAT IT'S LIKE TO be the only female person of color in a room, what it's like to see your father, brothers, and people being targeted for their color and religious articles of faith. You don't know what it's like to wish you weren't brown as a kid and always be insecure of where you came from. Everyone asks me, 'Why are you driven to do so much?' I don't know how to answer that question but eventually I learned from myself that I want to make my parents proud. It's the endless things they gave up for me, it's the struggles they went through and continue going through to give me the life that I have. It's my burning passion for change. It's how I was raised. I have the freedom to work as hard as I want to and it's for the two people who showed what it means to be different, unique, and rare."

Komalpreet K.
Age 16 /
High School Student
OLATHE, KS
22 JAN 2021

195

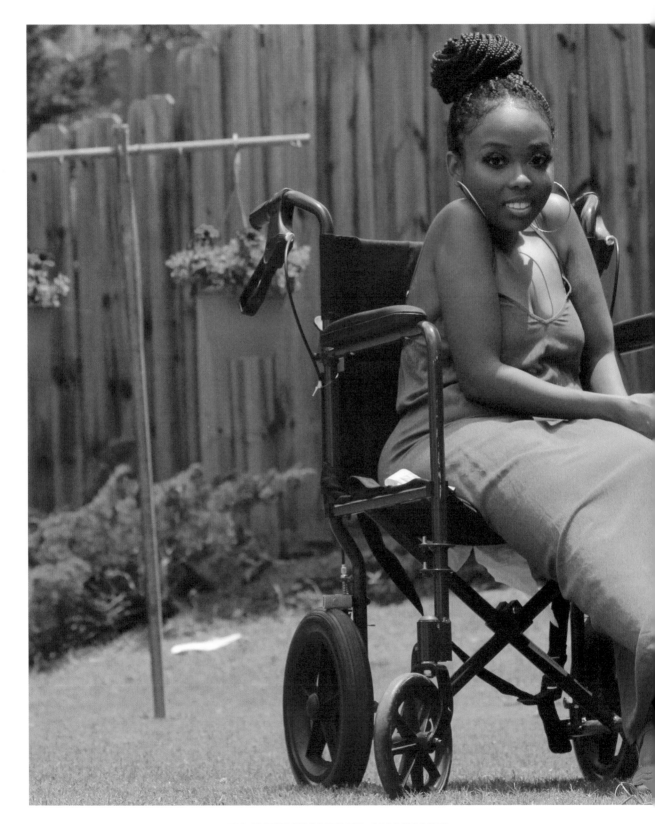

"**MY LIFE RIGHT NOW** is seeing life in 20/20 vision. This pandemic has made me realize how quickly life can change and there's nothing you can do about it but go with it. I have learned that with this quick change comes a different perspective in life, my life. I had to see my life in a different lens, I couldn't continue to self-sabotage just because I feel like since I have a disability, there's no opportunity for me. I realized that I needed to follow through with my goals because it could create hope which is needed right now. This pandemic also made me realize the importance of communication with loved ones. I started to call my family and friends more because life can be short and you just never know when it's time. This pandemic has hit hard, but it does help you see life more clearly."

Nila M.

Age 21

GREENVILLE, SC
04 SEP 2020

"What keeps me up at
night is the sound of
my biological clock
ticking. My lifelong
American dream
has always been to
become a mother,
but here I am still
single at age 35.
I have decided to
end my search for
the 'right man' and
take the reins of my
future happiness
with the help of an
anonymous sperm
donor, instead."

Anonymous

WEST HOLLYWOOD, CA
17 JAN 2020

MAY · 56

"I WAS RAISED TO BELIEVE that a girl's place really was to get married and have babies. My father said, 'Linda, it'll be a waste of time to go to college, you're just going to get married and have babies,' but I thought 'I can do both.' . . . I worked for 50 cents an hour plus half my tuition and 10 years and 4 kids later I got my Master's degree."

Linda D.

Age 81 / Retired, Travel Tour Leader /
Oklahoma Teachers Association

YUKON, OK
15 JAN 2020

"LOOKING AHEAD, I have a lot of dreams. I am often dreaming about who I want to be and where I see myself in the future, which has many answers, because I want to be the first one in my family to enter college in the United States, an inspiration to my Hispanic community, independent, and successful."

Anonymous >

MINNEAPOLIS, MN
16 JAN 2021

"MY LIFE RIGHT NOW . . .
I had a criminal background that I had to take responsibility for. It wasn't easy. Second chances are not given, for sure. But I kept my faith. Next year I start my Doctorate's Degree . . .
You have to believe. No one but you can make it happen. And it takes a lot of hard work. You simply cannot give up! Nothing was ever given to me. Matter of fact, people only saw my past record. But I said 'That is NOT who I am!'"

David O. >

GREENVILLE, SC
06 JAN 2021

"MY AMERICAN STORY STARTED WHEN my grandfather jumped on a ship as a stowaway from Germany to New York City."

Rick S. ∧

SCROGGINS, TX
15 NOV 2019

"You don't know what it's like to be a Samoan student. To have to scavenge for opportunities for work and school on such a minuscule island and to view the military and American football as your only occupational options are things you will never experience. You don't know how it feels to have imposter syndrome every time you participate in national programs or to be expected to produce insignificant accomplishments in comparison to your international peers. You don't know what it's like to make efforts to preserve your island, culture, and GPA simultaneously. You don't get to feel pride as you wear the fabric of your culture and history on your back or as you speak your mother tongue every morning in prayer. You don't know what it's like to be loved and supported by such a family-oriented community."

Audrey S.

Student

PAGO PAGO, AS
04 NOV 2020

"MY AMERICAN STORY STARTED WHEN my grandfather landed on Ellis Island from Italy in 1923. That's him on the right, circa 1935, in front of his coal-and-ice delivery truck with my uncle and father."

Craig D. >

BROOKLYN, NY
05 DEC 2019

"MY AMERICAN STORY STARTED WHEN I was six years old. I was born in Pakistan, and my dad won lottery tickets that allowed for us to move to America!"

Fatima S. ∧

JESSUP, MD
06 DEC 2019

"I TOOK A RISK WHEN I married my husband a week before we moved to Fort Knox so he could pursue his dream of being an officer in the United States Army. We had no family there. I did not have a job and we were so naive."

Amy S. <

CRANBERRY TOWNSHIP, PA
03 APR 2020

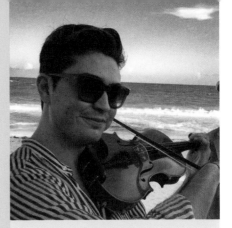

"MY AMERICAN STORY STARTED WHEN I was 9 months old. My grandfather told my dad to walk the Trail of Tears so my parents taking me in a backpack and supplies on a horse started the journey of traveling 14,000 recorded miles by horse through 34 states as I grew up . . . It always amazes me how seemingly small insignificant actions can through the power of people add up to massive change."

Aur B. ∨

CARBONDALE, IL
09 JUL 2020

"A DAY'S WORK IS practicing my instrument . . . My viola has been a musical passport for many years."

Ray A. ∧

LAS CRUCES, NM
15 JAN 2020

"WHEN I STEP OUTSIDE MY DOOR I see the backdrop of the San Francisco Bay Bridge. I moved across the country at 25, leaving behind a great job and tons of friends to start over and move to the Bay Area. I never felt connected to Raleigh, where I'm from, but out here, I feel in tune with it all, like I'm supposed to be taking it all in . . . Life is about seeing new things and meeting new people, so why not uproot it all."

Emily W. ∨

SAN FRANCISCO, CA
23 OCT 2019

"WHEN I STEP OUTSIDE MY DOOR I see tall skyscrapers and a lot of opportunity. The air is filled with NYC energy and anxiety which I have learned to use as fuel for my success."

Louis B. ∧

NEW YORK, NY
19 DEC 2019

"**MY AMERICAN DREAM** was inspired by my Aunt Evelyn. I learned from her that a good education can open the mind as well as doors to opportunity and adventure. She wrote, 'A classroom can be as vast as the infinite reaches.' Her life did not begin with the silver spoon metaphor. It would seem she was up against virtually every kind of roadblock. Her parents were immigrants who came through Ellis Island in the early part of the last century, speaking no English. Evelyn would become one of the youngest woman reporters for *The Miami Herald*, a *Time* magazine correspondent, a student archeologist and a college professor. She also explored the Caribbean in a sailboat and worked briefly in espionage, all in one short life. She did investigative reporting long before it was vogue. Her life remains an inspiration."

Edward J. ⟨
PEPEEKEO, HI
17 OCT 2020

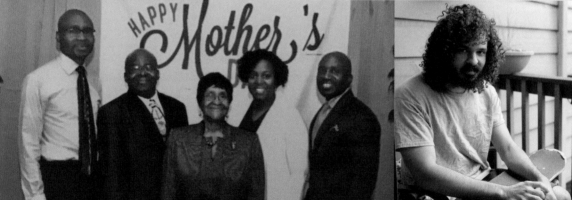

"**MY AMERICAN DREAM** is where racial bias would be a thing of the past, where citizens can walk the streets in peace, government leaders will do the work they were elected to do, elderly citizens live out their years. I would love to see my nieces and nephews have a better life than I did, a better education and employment opportunities to a better future. In order for a dream like this to come true, we need nation builders instead of someone tearing it down."

Kenneth J. ∧
SAVANNAH, GA
30 SEP 2020

"**I TOOK A RISK WHEN** I moved to Alaska to escape the Lower 48 with no job nor place to live when I landed. I am searching for purposeful work as we march toward winter."

Anthony H. ∧
ANCHORAGE, AK
30 SEP 2020
Image by Mary Katzke

"MY AMERICAN DREAM was to be the tenth generation Quaker farmer on land deeded to my family way before the United States of America became a country. This was not meant to be. The government of New Jersey decided to put two major highways right through the middle of the farm. My father decided it would be impossible to continue farming tomatoes, corn, fruit and other produce between two very busy highways. He sold the farm, and I went on to get my Ph.D. in Marine Biology. And so . . . my American Dream had to change."

Kristina V. ⟨
CHRISTIANSTED, VI
12 OCT 2020

"WHAT GETS ME OUT OF BED IN THE MORNING IS knowing that because I awoke, there is an opportunity to make change in my community. I understand that the gift of life was not always something I looked forward to, or thought would have lasted to this point in my life. My expectations were not always personally positive, yet my higher power consistently breathed life into me on a daily basis. This for me means I have purpose, and must embrace that and be that catalyst for others."

Brian A. ⟨
NIAGARA FALLS, NY
20 OCT 2020

"I TOOK A RISK WHEN I, a high school dropout who became a mom at 17, felt compelled later in life to redefine myself . . . The journey took ten years and numerous tears, but now, I have a Master's degree . . ."

Patricia M. ∧
WEST COVINA, CA
06 JUL 2020

"WHAT GETS ME OUT OF BED IN THE MORNING IS the possibility of new things surprising me . . . " DUSTIN H. — VENTURA, CA

"My American story started when I came to the United States in 1979, married to someone I barely knew. I grew up in India and mine was an arranged marriage . . . I was 23, had never dated, didn't know any guys, and grew up with sisters . . . We were both great people individually; together we were not! Both strong personalities, both intellectual, and neither willing to give in. My American story is that I grew into an independent, vocal, and giving woman; nothing like the good wife and mother I was raised to be. Thank you America for providing the environment for me to be who I am meant to be."

Farida G.

Age 64 / Happily Retired

COLUMBIA, MD
28 OCT 2020

"MY AMERICAN DREAM is to be a baseball player . . . I get that watching is not that fun but when you're out on the field with your teammates there is no other feeling. That's the only sport I can see myself playing when I get older but I do have a backup plan if I don't make it but my plan is to make it."

Anonymous

DOLTON, IL
30 AUG 2020

"I TOOK A RISK WHEN I quit the housekeeping job that I worked for 9 years. I told myself that I want to have a better life by going to school and I can't be stuck to something that I don't really like. At my age of 35, I am hoping that it is not too late to have a better career for my future and that I can be proud of."

Raymond R.

Age 35 / Unemployed

HAYWARD, CA
11 DEC 2020

"I WAS RAISED TO BELIEVE that if you don't ask, the answer is always no . . . My dad has ingrained this saying into me. He wanted me to remember that taking risks and putting myself out there could open doors into opportunities that might not normally be offered to me. Of course, there are times when the answer is actually no, but I always feel better taking a chance than wondering 'What if?'"

Steph R.

Art Educator

NEWARK, DE
31 AUG 2020

"I WAS RAISED TO BELIEVE that you should take care of your family. Like many Asian American families, my parents sacrificed hours in the kitchen at a Chinese restaurant so me and my siblings have the freedom to choose what we do with our lives."

Anonymous

ROCKVILLE, MD
08 APR 2020

"MY AMERICAN DREAM is complicated. My grandfather was a Holocaust escapee, so for him, an American dream meant safety, and that's how I understood it. The idea of an American dream means safety and security to many, but also material success and social mobility, which many people do not have. In this way, it's a fallacy to say that if people can just make it to this country, they will have access to the 'American dream.' Many people do not have safety and security in this country. I hope we can have a nuanced conversation about what the 'American dream' means and who has been able to access it."

Anonymous

DENVER, CO
11 AUG 2020

"Love is or it ain't. Thin love ain't love at all."

—Toni Morrison

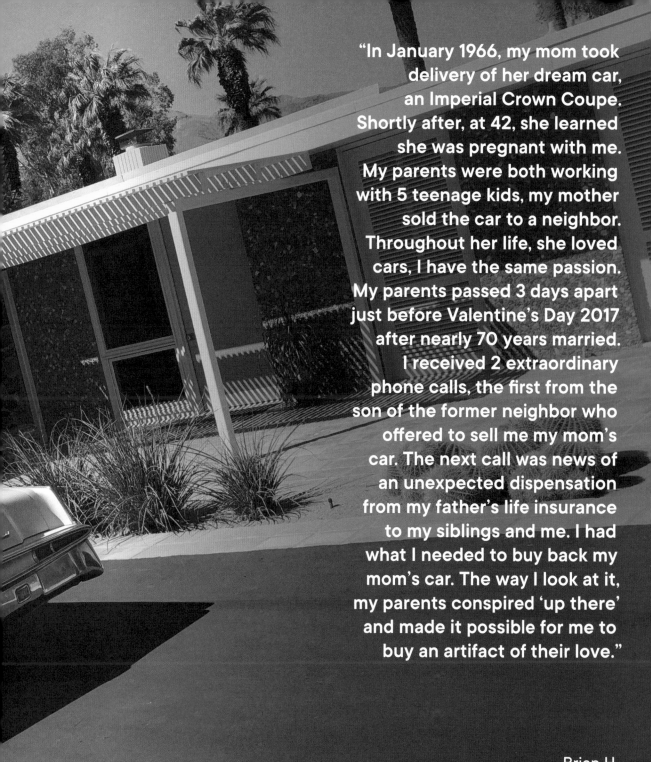

"In January 1966, my mom took delivery of her dream car, an Imperial Crown Coupe. Shortly after, at 42, she learned she was pregnant with me. My parents were both working with 5 teenage kids, my mother sold the car to a neighbor. Throughout her life, she loved cars, I have the same passion. My parents passed 3 days apart just before Valentine's Day 2017 after nearly 70 years married. I received 2 extraordinary phone calls, the first from the son of the former neighbor who offered to sell me my mom's car. The next call was news of an unexpected dispensation from my father's life insurance to my siblings and me. I had what I needed to buy back my mom's car. The way I look at it, my parents conspired 'up there' and made it possible for me to buy an artifact of their love."

Brian H.
Age 54 / Professor & Educator
SAN DIEGO, CA
11 JAN 2021

"MY AMERICAN STORY STARTED WHEN my mom fell in love with my dad while he was stationed in South Korea in the mid-70s. She trusted in her love and moved to America, leaving her life in Korea behind. Over 30 years later, language and cultural barriers haven't stood in the way of their love."

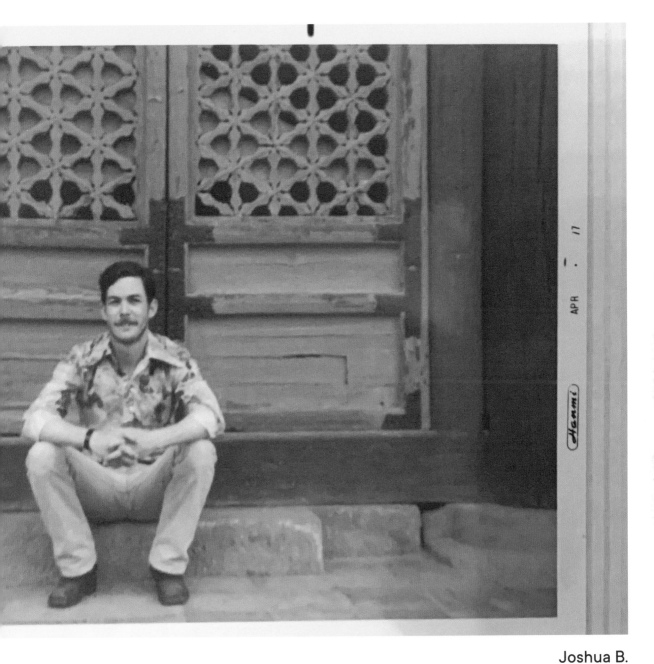

Joshua B.

Age 38 / Creative Director

NEW YORK, NY
10 FEB 2020

"I never expected that I would actually love being single, and love my tiny living space, and love working on a hilarious comedy show, for free."

Bridget M.
CHICAGO, IL
13 AUG 2020

"AT THIS POINT IN MY LIFE, I have decided to just love my body. Some days that looks like putting on an outfit, walking around, feeling myself, saying surely I must be breaking necks. And some days that means I look down at my legs and I remind myself, I don't hate them . . . It takes work. It's work to feel it, to work, to say thank you to my body for just being a body. But I don't hate my body anymore. At this point in my life, I get to love my body."

Hileena C.
DENVER, CO
01 DEC 2020

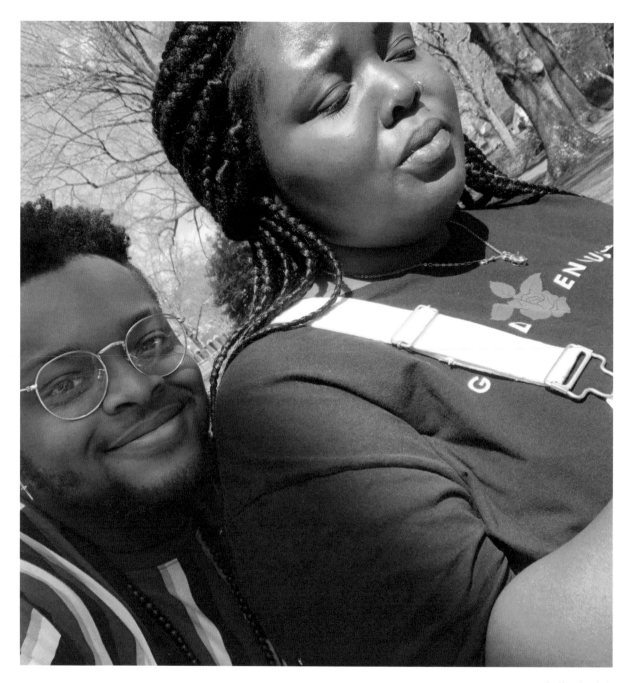

"**FAMILY LOOKS LIKE** unconditional love and support but that doesn't mean blind love. It means holding each other accountable and being there even when times are the hardest. Expressing yourself openly and freely while respecting each other's boundaries. Pissing each other off and being able to laugh about it an hour later. Sometimes family looks [like] prioritizing yourself while having someone you care about support you."

Ja'Lain M.
RALEIGH, NC
09 JUN 2020

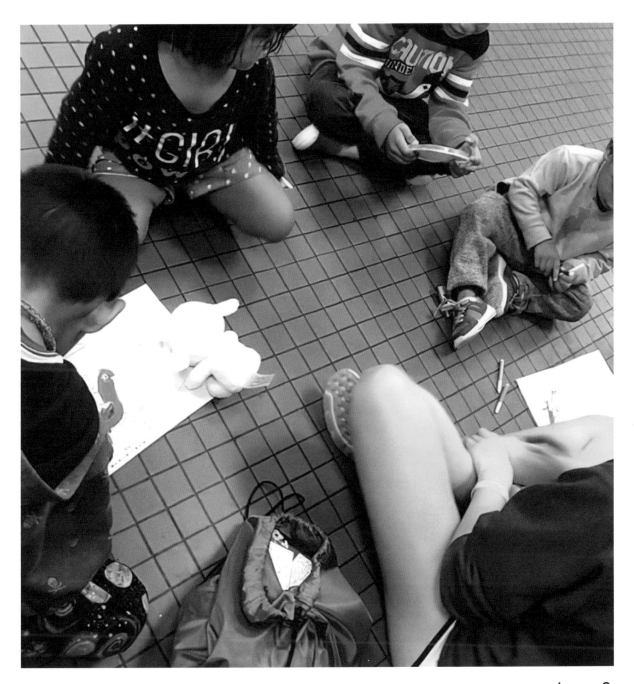

"**I NEVER EXPECTED** to spend my Friday nights at the Charlotte Greyhound Bus Station at 2:00 a.m. with migrant children. I also never expected that the so-called 'land of opportunity' was capable of stripping kids of their innocence, but I was wrong. The U.S. stripped these innocent children of everything: their innocence, their dignity, and their childhood. It was my job to restore what I could."

Laura S.

Age 17

CHARLOTTE, NC
11 JAN 2021

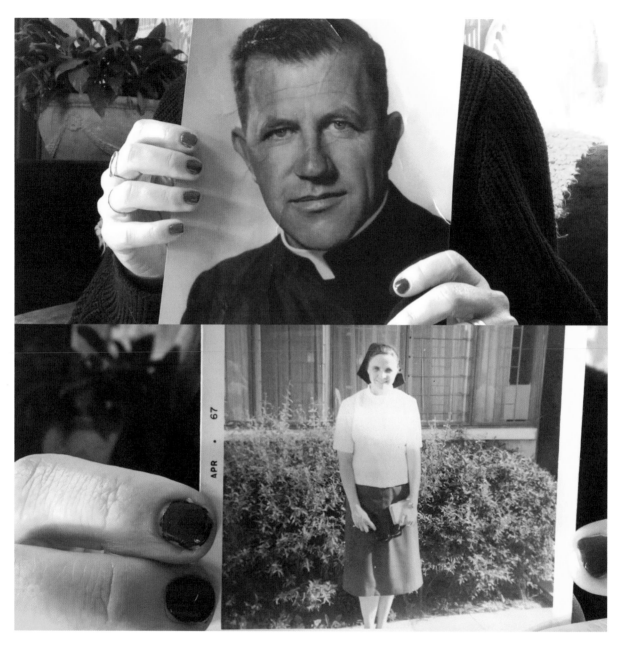

"**I NEVER EXPECTED** . . . This was my dad. And I know it's probably not okay to say this, but I think he was a pretty hot priest. My mother was a nun. And what began as a really beautiful friendship that started with shared values led them to questioning whether or not they should commit to the church or to each other . . . What my father would say was serving God in a different way: building a family with my mom."

Sara A.

Filmmaker

PROVIDENCE, RI
10 JAN 2020

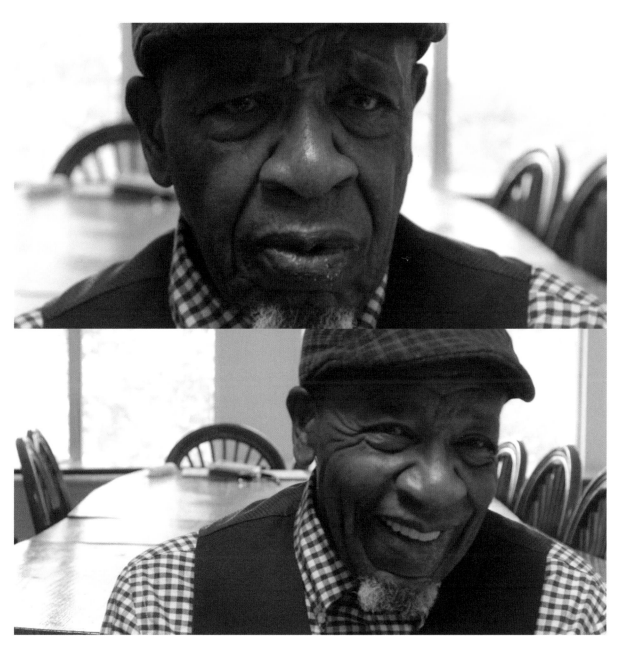

"**AT THIS POINT IN MY LIFE**, I am trying to love people and help people love one another. I'd like to say what Rodney King, the first Black that was shown all over the world, [said:] 'Can't we all get along.' Can't we all get along? I think it might be possible. We might not all be able to get along, but some of us could love one another and it could become a little contagious."

Dr. John M. P.

Age 90 / Pastor of Common Ground Covenant Church

JACKSON, MS
17 AUG 2020

Images by R. D. & Ashley Chisholm

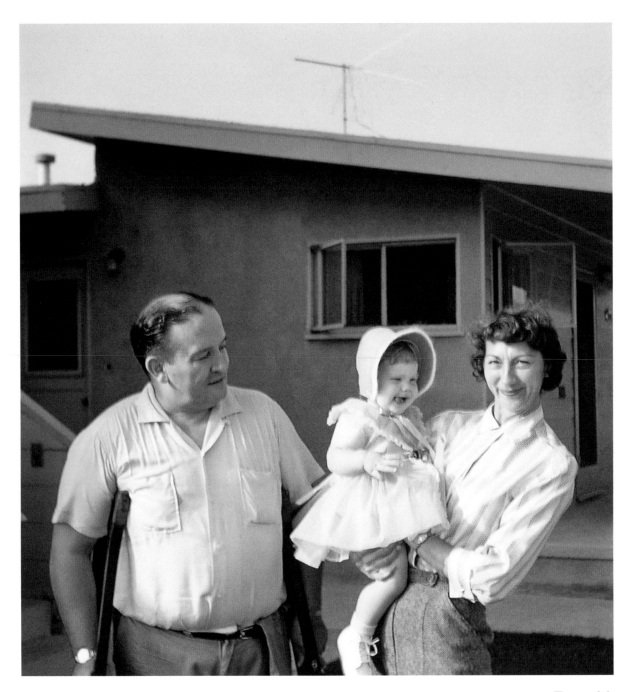

"I WAS RAISED TO BELIEVE I was loved because my grandparents were there each time my father or mother decided raising five children was a drag. Mom swapped her bouffant and capri slacks to go find herself, returning as a mini-skirted college student, pretending her five offspring were Nana and BaBa's responsibility. 'Those were the happiest years of our lives,' Nana said often . . . Any fear of death ended for me after they were both gone. When that day arrives I will be with them once again. That would be heaven."

Tracy M.

Age 60

**THOUSAND OAKS, CA
24 NOV 2020**

PBS AMERICAN PORTRAIT : LOVE

"WHAT GETS ME OUT OF BED IN THE MORNING IS . . ."

Anonymous
REDONDO BEACH, CA
03 FEB 2020

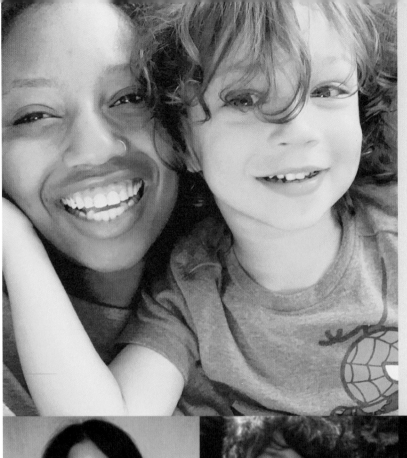

"MY SATURDAY NIGHT LOOKS LIKE me and my little man. I spent every Saturday night doing whatever HE chooses. From pancake dinners to watching *Toy Story* the 100th time, I want him to know beyond a shadow of a doubt that he is loved and there is someone out there that cares about his happiness."

Qarman W. ‹

BURTONSVILLE, MD
16 DEC 2019

"WHEN THIS IS OVER I'm going to fly 2,500 miles to see my son in the flesh. Technology keeps me from going insane, but it's also made me appreciate the value of being with another human being."

Victoria S. ∧

SUNNYSIDE, NY
09 MAY 2020

"WHAT GETS ME OUT OF BED IN THE MORNING IS waking up to make my fiancée coffee. I love her but she is bad at making coffee."

Phillip M. ∧

BROOKLYN, NY
24 OCT 2019

"I TOOK A RISK WHEN I fell in love in the middle of a pandemic. We met on the Internet, as all young love does these days. Our first dates were exclusively virtual, FaceTimes and phone calls lasting ages . . . We fell in love in a strange time where dates were outside, six feet apart, and covered in hand sanitizer . . . We ended up doing inside activities . . . like baking. A lot of baking. We've mastered the peasant bread recipe. Now six months in, she's been the best part of my year."

Lumiere R. 〈
TAMPA, FL
07 JAN 2021

"MY SATURDAY NIGHT LOOKS LIKE date night with my kitchen. Keeping it fresh. I love experimenting with recipes. I discovered recently this new love for cooking and I'm realizing it's brought out a passion I never knew I had. Food like music is an international language."

James N. 〉
EASTON, PA
02 FEB 2020

"WHAT GETS ME OUT OF BED IN THE MORNING IS my sister and my mom. I love them a lot, but I love my dog, Archie, way more."

Vianneth J. ∧
MESA, AZ
06 DEC 2019

"I WAS RAISED TO BELIEVE that love can never be extraordinary . . . love can only be unsatisfactory or miserable." CHERAH L.—DESOTO, TX

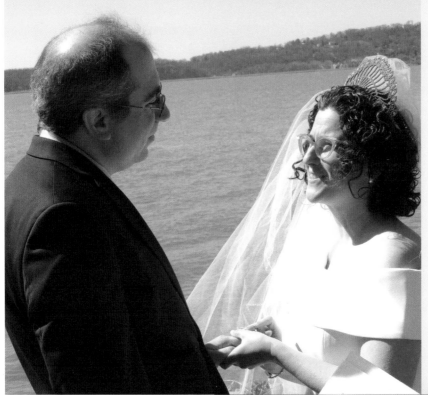

"I NEVER EXPECTED
to have my officiant's
son as my best
man, maid of honor
and musician at my
wedding, but he did
a great job.
I never expected to
get married without
our moms there,
but they need to
maintain strict
social distancing."

Rebecca S. ‹
NEW YORK, NY
17 MAR 2020

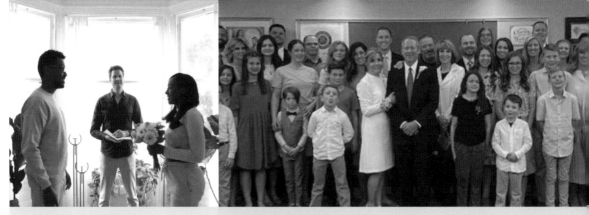

"I NEVER EXPECTED
my wedding to be like this . . .
We will have another date
in the near future where we
can all get together . . . Rest
assured love is not canceled."

Tamar & Stonly B. ^
SAN FRANCISCO, CA
04 MAY 2020

"I NEVER EXPECTED . . . We got sick just days after we got
married. Like, really sick . . . He really had to take care of me
pretty heavily for several days . . . I didn't expect, this early
on in our marriage, to have to spend 24 hours a day with each
other, and not being able to leave the house. We feel like we
can tackle anything now."

Susan and Craig M. ^
MCCALL, ID
10 APR 2020

Image by Colleen Kelly Poplin

"I NEVER EXPECTED . . . In 1973 I met a guy who I knew I wanted to spend the rest of my life with . . . and I did." MEG K. – ERIE, PA

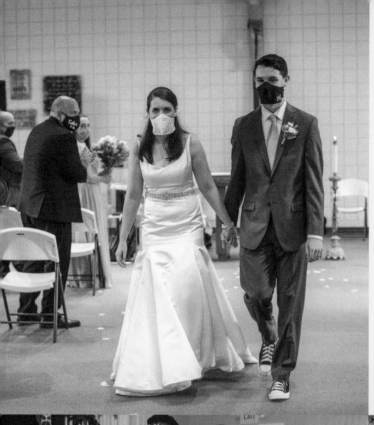

"I NEVER EXPECTED . . .
We made the best out of a bad situation. Thanks to the help of our local church, we were able to have our immediate family there as we exchanged our vows and set up a Zoom for all of our loved ones to tune in virtually."

Taylor B. ‹
EAST RUTHERFORD, NJ
19 DEC 2020

"I NEVER EXPECTED . . . I'm married to and living every day with my best friend in the whole wide world . . . It's a platonic friendship that we let blossom into a romance, that we let progress into a monogamous partnership, that we let progress into marriage . . . Being friends is the foundation."

The E.C. Family ^
WILMINGTON, DE
27 JUN 2020

"I NEVER EXPECTED . . .
The beach we were to be married on closed, the restaurant we were using closed . . . the love we feel still the same!"

Mindy F. ^
MYRTLE BEACH, SC
04 MAY 2020

"I took a risk when I fell in love with a man who wasn't the same religion as my family in 1986. It took a few years for me to realize that I had to have confidence and be willing to stand up for LOVE. We are now happily married for 26 years with both families having grown to love each other and the different traditions."

Alka K.

Yoga Instructor / Present Wisdom
ARMONK, NY
23 APR 2020

"FAMILY LOOKS LIKE two longtime friends who came together in our 60's to care and live with each other. We're not married or even a couple but we've been friends for 45 years and neither of us had anyone anymore. My husband died in 1996 and Marty's husband left him after 33 years. We were both alone and didn't want to be a burden on our families. We decided to help each other!"

Dena K.

Age 64 / Theater Stage Manager / Actors Equity Association

**SILVER SPRING, MD
23 NOV 2020**

"I TOOK A RISK WHEN I went to Belize and met a cute pilot on our flight over the Blue Hole. We had chemistry immediately. I looked him up on Facebook after the flight. He asked me to spend my final evening with him. We stood on the motorcycle while driving down the dirt road. One of my best nights. The biggest risk is with my heart hoping every day that we'll meet again now that we're both living in Texas, but 8 hrs away. I just want 5 more minutes of that feeling."

Kate S.

Age 31 / Teacher

**HOUSTON, TX
25 SEP 2020**

"MOST DAYS I FEEL like the most blessed person around. I just married a wonderful man I have known since we were teenagers and he has given me a beautiful life. I am grateful."

Angela V.

President, Women in Film Arkansas, Screenwriter / Women in Film Arkansas

**BURBANK, CA
01 FEB 2020**

"I TOOK A RISK WHEN I agreed to go to a Thanksgiving dinner at a stranger's home. I'd spent two hours talking with a guy in a spa at a hotel. He asked what I was doing for Thanksgiving and I said I was staying home. Then came the invite, and my surprise YES. It turned out to be a naked party one host had accepted an invitation to; the other guy planned a day-after Thanksgiving party (clothes on!). The first party was fine (after the initial shock). The second party was great. The host told me that there was only one other single guy there, and that I probably wouldn't like him. I had to find out who I probably wouldn't like. He is my partner of 12 years!!"

Bradley B.

Age 56 / Disabled

**CATHEDRAL CITY, CA
01 AUG 2020**

HO

PE

"The most valuable possession you can own is an open heart."

—Carlos Santana

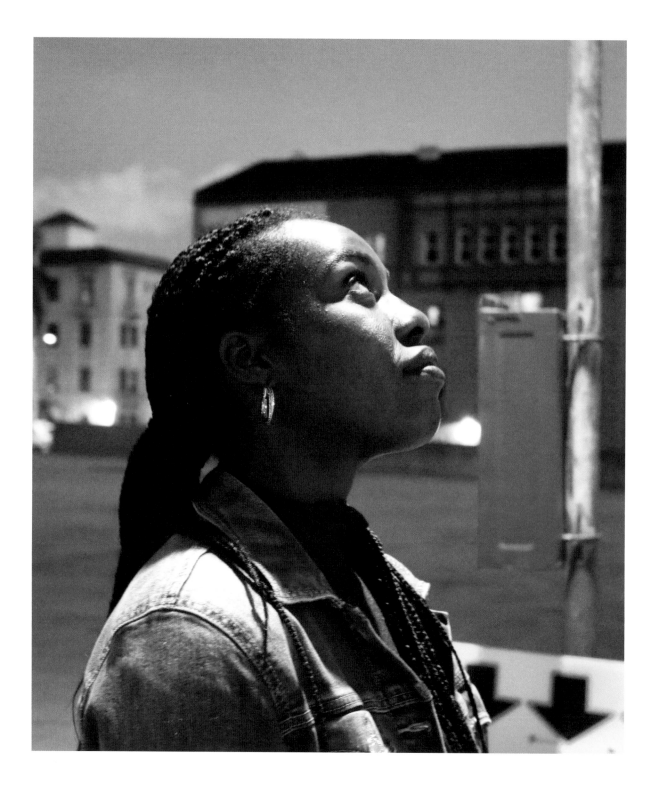

"When I step outside my door, I want to come back a bit different than when I left."

Opeyemi F.

Age 22 / Environmental Specialist

RESEDA, CA
09 MAR 2020

Image by Princess Garrett

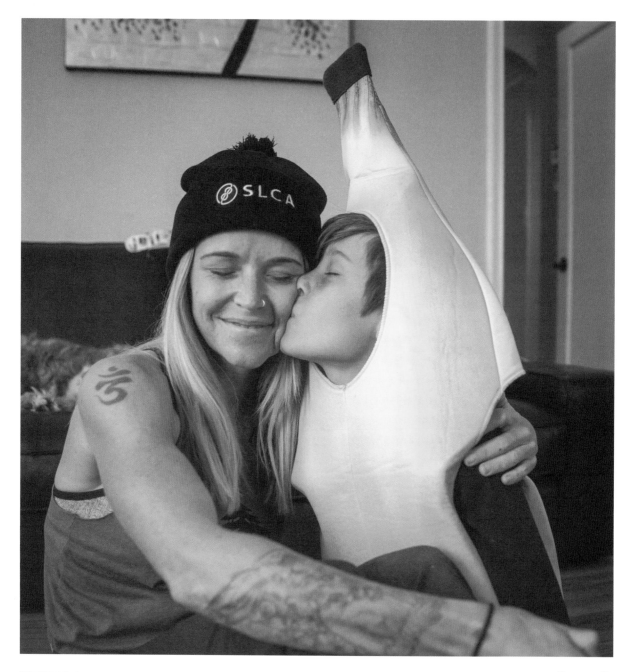

"**AT THIS POINT IN MY LIFE**, life is pretty awesome. I have 2 hilarious and adorable kids, I just got into nursing school, and I am excelling in my sports (AKA my medicine). Not everything is perfect, my marriage isn't perfect, I miss my Dad who I've not been able to see much since Covid, and my car is not currently working. But at the end of the day, I have so much love surrounding me and I'm doing the things that make me happy. I'm finally achieving all the goals I wasn't sure I was good enough to ever achieve. Life is never going to be perfect, but perfect is boring anyway!"

Dona C.
Nursing Student & Mother
SALT LAKE CITY, UT
21 OCT 2020

PBS AMERICAN PORTRAIT : HOPE

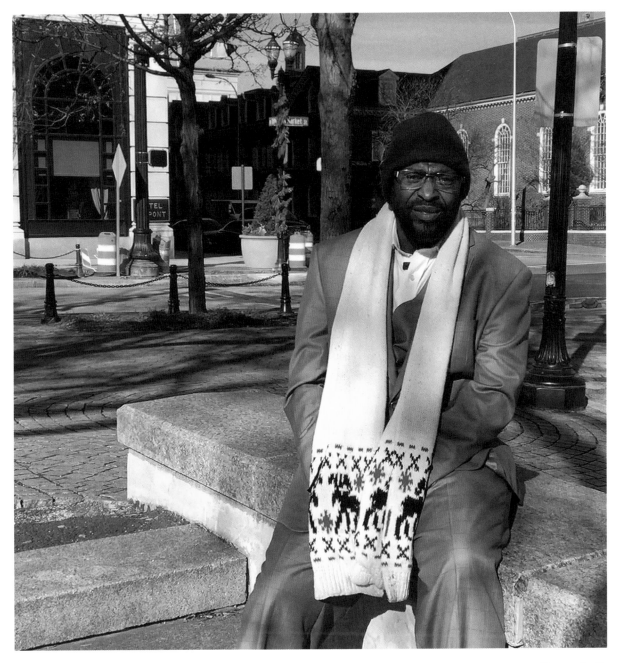

"WHAT GETS ME OUT OF BED IN THE MORNING IS wanting to live, because I've been infected with the HIV virus since 2000."

Francis S.

WILMINGTON, DE
02 JAN 2020

"I TOOK A RISK WHEN I left everything to live authentically. I was about to have to move back in with my parents and go back into the closet if I did so. I was assigned female at birth, but realized I was a guy at a young age. I couldn't hide anymore. Moving back in with my parents, I would have gone back to school, graduated in the spring, had health insurance, wouldn't have to pay for food / living situation, as long as I was fine with denying who I was. I took the risk and got on the midnight train heading toward DC. I went to Virginia, got a job in politics, and am almost getting by. Even though money is tight and my dreams seem farther than possible, I am definitely happier and healthier because I can be myself. Because I can be Apollo."

Apollo Q.

Age 21 / Field Organizer

MANASSAS, VA
31 JAN 2020

"YOU DON'T KNOW WHAT IT'S LIKE TO lose your virginity by rape. You also don't know that it may have happened to someone close to you. My family had no idea that I was a victim of Intimate Partner Violence for 3 years. I came home for dinner pretending like I was ok. Nobody saw beyond my desperate attempts to hide the crimes against me. Even when authorities had a chance to see signs of abuse, they chose to believe my fake smile. I once had a door shut in my face. I wasn't smiling then. I became suicidal. I didn't want to live and didn't want to die. Thankfully, I decided not to take my own life. With support, I became a survivor. Living in recovery isn't always easy, but I'm empowered every time my smile is real. So, you may not know what it's like to have something special taken from you, but now you know a story of hope."

Elizabeth C.

NoStigmas

CANOGA PARK, CA
16 SEP 2020

"Looking ahead,
I wonder constantly
if being optimistic
makes me naive.
Regardless,
optimism is the
only way in which
I can interact with
the world and the
future. It is what
gives me peace
and strength."

Andrew G.

Age 19 / Student

OLD GREENWICH, CT
13 NOV 2020

"**MOST DAYS I FEEL** happy."

RyNiah E.

Age 7

LUBBOCK, TX
10 AUG 2020

"WHAT GETS ME OUT OF BED IN THE MORNING IS a passion I have for the fulfillment of human potential, my human potential and everyone else's human potential." **CONNIE L. — CHICAGO, IL**

"WHAT GETS ME OUT OF BED IN THE MORNING IS that I can try a little harder each day to bring some healing to kids in our community." **DENISE M. — PROVIDENCE, RI**

"I TOOK A RISK WHEN I decided to help those in need during this COVID 19 crisis. It is my duty as a first responder to help." **YURI W. — LONG BEACH, CA**

"LOOKING AHEAD, I . . . the work I've created in 2020 has been very introspective. Created during this period of isolation, my work has tended to reflect on the darker forces humanity faces. I'm ready to say goodbye to 2020, with the hope that in 2021, we will be able to come out of the darkness and into the light." **BLAIR T. — BEMIDJI, MN**

Images by Max Rasmussen

"AT THIS POINT IN MY LIFE, I'm entering my middle years just finding the confidence to use my voice. In my shy and asthmatic youth, I mostly lived inside my imagination. I'm grateful to have spent the last decade sharing others' voices by photographing my hometown, focusing on the underrepresented. I carry these stories in my heart—such as the pregnant homeless teen, forced to sleep in frozen winter doorways and still with the generosity to offer me food gifts. I recently became a photo teacher and enjoy relating these experiences. It gives my students greater understanding of our community while strengthening the words of those I photographed. With this inspiration, I've learned the importance of sharing my knowledge—especially to help young women find their own unique voice and self-worth through artistic expression."

Niki W. >

SALT LAKE CITY, UT
03 NOV 2020

"I NEVER EXPECTED to lose a child. As a Nurse Practitioner . . . I never wanted any of my patients to fear death. I would explain that dying was just like when you are born: You are in a warm bath, you hear your mom's voice and heart beat, you know how she tastes and her smell, then a force so strong pushes you out and you're scared, then you hear muffled voices and see the bright lights and cry. But soon you are lifted and placed on your momma's chest and you can smell her and you know you are home and stop crying. This is what death is like, going from one room to the next."

Christine C. ‹

MONTEREY PARK, CA
27 AUG 2020

"NOW IS THE TIME for ALL of us to come together, the whole world, to piece together this broken heart we all own."

Anonymous ∧

LIVONIA, MI
29 DEC 2020

"MOST DAYS I FEEL pretty awesome . . . Today, just like any other day, I feel great. And I am not going to let anyone change that."

John M. ∧

SALT LAKE CITY, UT
02 JAN 2020

"I NEVER EXPECTED to be able to paint. I'm most drawn to portraits of my family—my parents and uncle when they were young and came to this country with big hopes for their future. Then there's my daughter and my niece (I have 10 nieces and nephews and 1 great niece)—my parents' hopes personified."

Elizabeth A. ‹
SOUTH BOSTON, MA
27 MAR 2020

"WHAT GETS ME OUT OF BED IN THE MORNING IS . . . losing a parent is hard, but when you can share what they've given you, it's the best. Cause I know I'll see her again. And then we can paint together."

Judy F. ∧
UNIONTOWN, WA
02 OCT 2019

"WHEN I STEP OUTSIDE MY DOOR . . . I have gratitude for my life as a retired teacher with my health and love from a supportive group of family and friends. With the breeze on my face, I'm ready to start the daily routine with my husband."

Francis P. ∧
SANDY, UT
26 OCT 2020
Image by Niki Chan Wylie

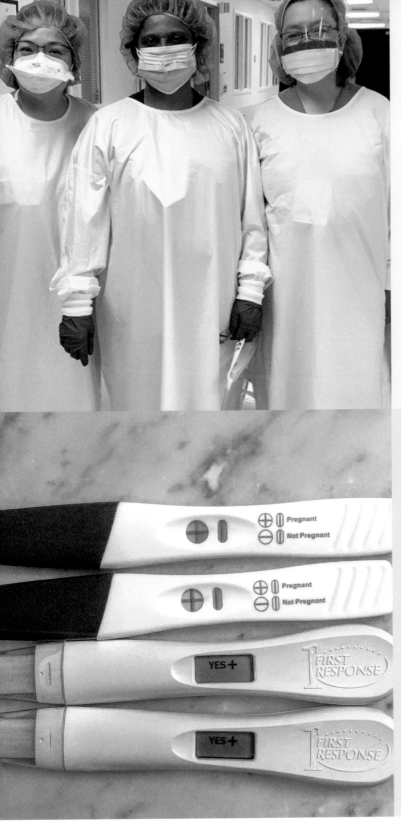

"WHEN THIS IS OVER
I will give my family the tightest hugs and a million kisses! . . . It's been several weeks since my self-quarantine at home. I love my family so I protect them . . . from me. Work has transitioned all of our nurses to staff Covid units . . . I look above my mask into the eyes of my patients comforted by the warmth of my hands, even though gloved, a gentle squeeze conveys support . . . We ALL need to hope."

Melissa T. ‹

MEDINAH, IL
07 MAY 2020

"I NEVER EXPECTED to have my first pregnancy in the middle of a pandemic. When our wedding was cancelled with no date in sight, my husband and I decided we didn't want to wait to start a family. Getting pregnant has been a burst of hope and joy in our lives; it's an important reminder that the world continues and we can still discover exciting and new things even during a pandemic. While there are things to be worried about and difficult aspects—such as not being able to visit our families—it has been an overall joyful experience."

Christina T. ‹

HONOLULU, HI
05 JAN 2021

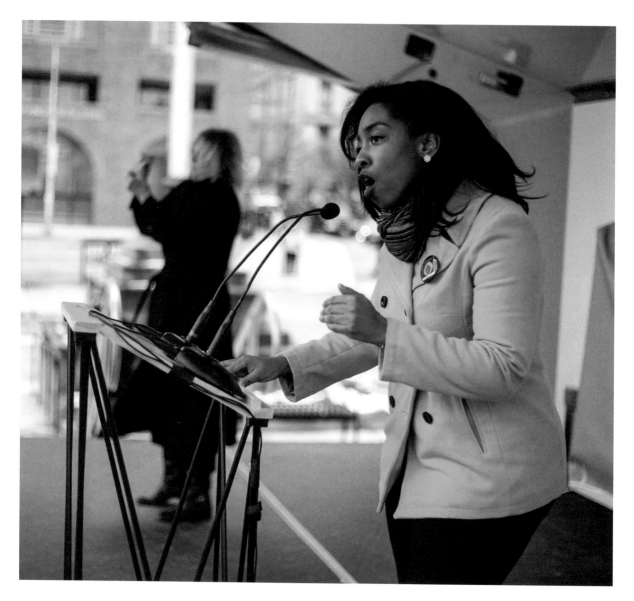

"**WHAT KEEPS ME UP AT NIGHT IS** knowing that I can change someone's life and make the world a better place. In times like these, I'd rather be overly ambitious than complacent because there are way too many lives at stake.

Having the profound ability to envision and implement a better world for everyone and everything around me is my super power and quite frankly, I just think it's worth a shot.

Every single human being on this planet should have an opportunity to obtain and secure stable, dignified housing, healthcare and education—the most basic needs to sustain modern life and should be guaranteed in a moral society—no matter what your zip code is."

Brittany O.
Age 31 / Civil and Women's Rights
Advocate, Policy Expert, Media Strategist

TOWSON, MD
09 MAR 2020

"You don't know what it's like to grow up being a child on welfare.

Your Mother working every angle she can to feed her children, going without food or water or electricity for extended periods of time. What is it like to have your head checked for lice or being pulled out of class to attend 'special' programs because your family has nothing? My mother had a strong will. She got me into college because she KNEW my capabilities, even when I didn't. I felt I was nothing. A person who had to stand in the back of the lunch line because I got 'free' meals. Eventually, I began to believe too. And I did. I graduated Cum Laude and worked, contributing to children who grew up just like me to beat the system of social and economic disparities. I know what it's like. I hope others can too."

Jayne J.

Age 63 / Occupational Therapist

BISHOPVILLE, MD
06 FEB 2020

"When this is over I am definitely thinking of stepping away from my tremendous anxiety of trying new things and speaking to people . . . I need to be more social if I truly want to experience life in the way that I want to . . . And I can't do that unless I get over my nerves . . ."

Anonymous

FORT WORTH, TX
13 JAN 2021

"WHEN THIS IS OVER, the first thing I'm going to do is to take my grandfather, who's 95 years old, to Costco. It's his favorite place in the world . . . And I want to be the one to take him there when it's safe for him to go out in public again . . . to buy paper towels in bulk, to try the samples . . . As simple as it sounds, it means the world to him."

Alan C.

Healthcare Consultant & Actor

NEW YORK, NY
11 MAY 2020

"WHEN THIS IS OVER I want to travel, travel, travel. I've always wanted to travel, but never had the money to do so. Never even been on an airplane at nearly 40 years old. I want to see the ruins of Pompeii and the catacombs of Paris . . . I'll have to scrimp and save and not buy anything but groceries and gasoline for a long while, but I'm determined to make it happen."

Toni A.

Age 39 / Homemaker

CHOCTAW, OK
10 MAY 2020

"WHEN THIS IS OVER I'm going to chase after the man I think I've fallen in love with. We met in college at UO last Fall and immediately clicked . . . We both had to go back home for social distancing . . . I've spent my quarantine at home thinking about him and the possibility of a future together. He just gets me in a way no one else has before, he's such a beautiful person. Wish me luck!"

Anonymous

BEND, OR
02 MAY 2020

"WHEN THIS IS OVER I am going to run up to people and kiss them full on the mouth, with consent. Or at least like a warning . . . When this is all over, and there's a vaccine, or we just don't have to worry about it anymore . . . oh my God. Will there be elation? Will there be orgiastic celebration? Will there be a lot of kissing and 'passing the mint'? I love that old party game, 'pass the mint.' All that will be happening. But until then, we'll just be careful. We'll live our lives the way that is wise—not necessarily fun. But there's a time for fun. There's a time to party and there's a time to keep your germs to yourself."

Martha G.

PHILADELPHIA, PA
17 JUL 2020

RESILI

"In America nobody says you have to keep the circumstances somebody else gives you."

—Amy Tan

ENCE

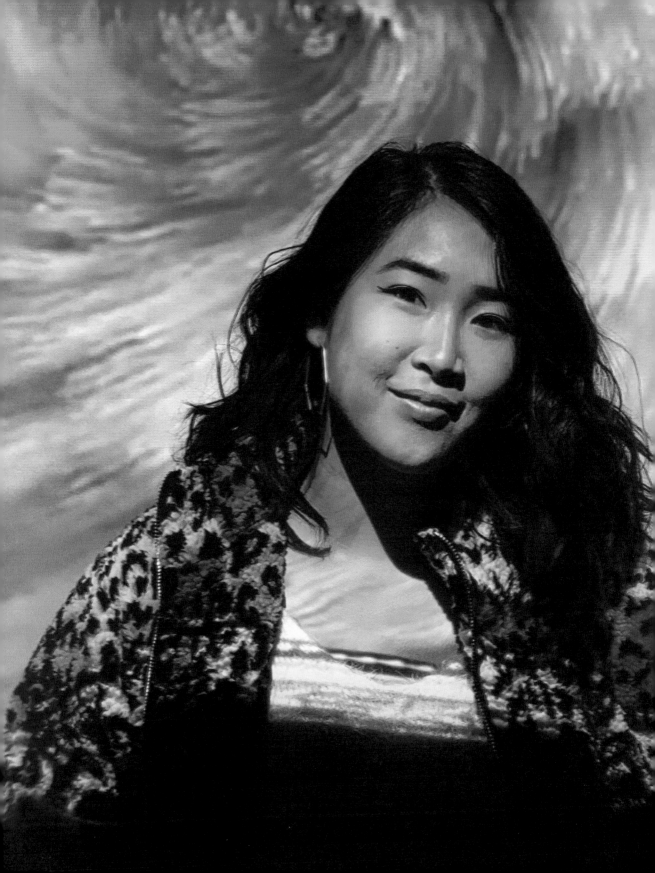

"In this chapter of my life I'm learning to heal old wounds, embrace my flaws and strive to become a better version of myself. I'm learning to trust the process and accept that growth is a slow but steady evolution. It may be an uphill battle but in the end, it's worth the struggle."

Aimee G.
LOS ANGELES, CA
18 DEC 2019

"My greatest challenge is making each day count. I don't want to start a trend, break a record or change the world.

I just want to feel at the end of the day that I didn't waste it. I create projects for myself each day. Weed that particular patch in my many flowers. Try a new recipe. Write a short devotional. Email a friend or write a note to let them know I think of them. Compliment a sales clerk. Just do something."

Sandy L.

Age 75 / Retired College Professor (Accounting)

GREENVILLE, IL
06 AUG 2020

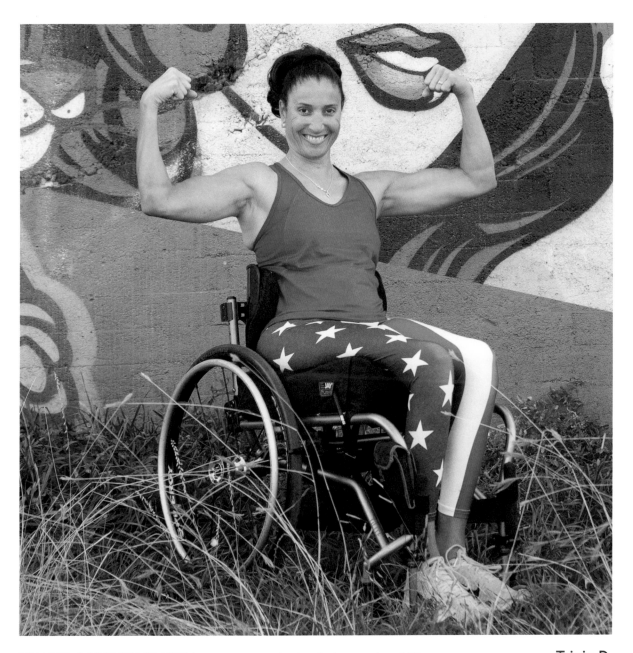

"**AT THIS POINT IN MY LIFE** I never expected, after being paralyzed 20 years ago, I could have a deeper appreciation and fully-rich life experience. Because of my disability, I have developed an independent and courageous spirit. These traits led me to compete in the Paralympic Games. I don't use the word 'confined' in the same sentence as 'wheelchair.' I may have differences in my abilities, but am still free to fly."

Tricia D.

Age 50 / Speaker / Writer / Team USA

DENVER, CO
05 AUG 2020

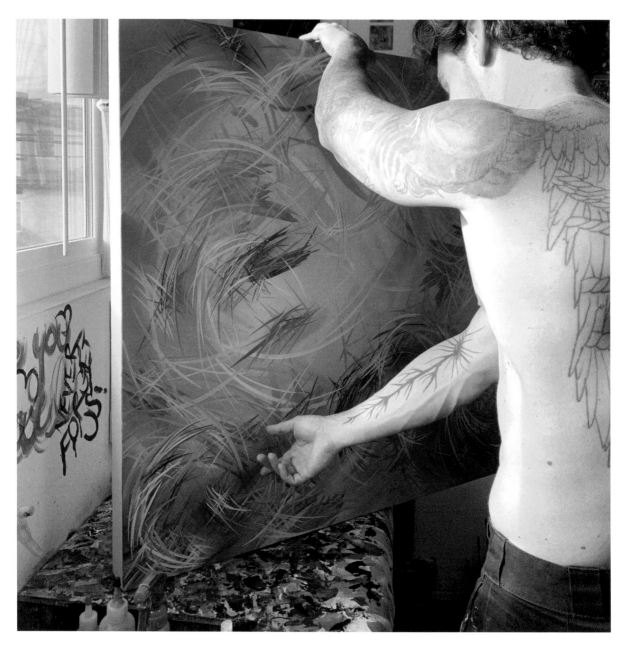

"A DAY'S WORK IS a dream. This is the life of a starving artist. A year ago I left all illusions of comfort because I saw no purpose to my life and I was ready to give up. I decided I would rather die going after everything I've ever dreamed of than continue living a life not meant for me. I dove 100% wholeheartedly into that dream and, in doing so, woke up. Now I wake up each day living my dream and sharing that dream to encourage others to do the same."

Michael C.

Age 35 / Artist / Carini Arts

SAN DIEGO, CA
27 MAR 2020

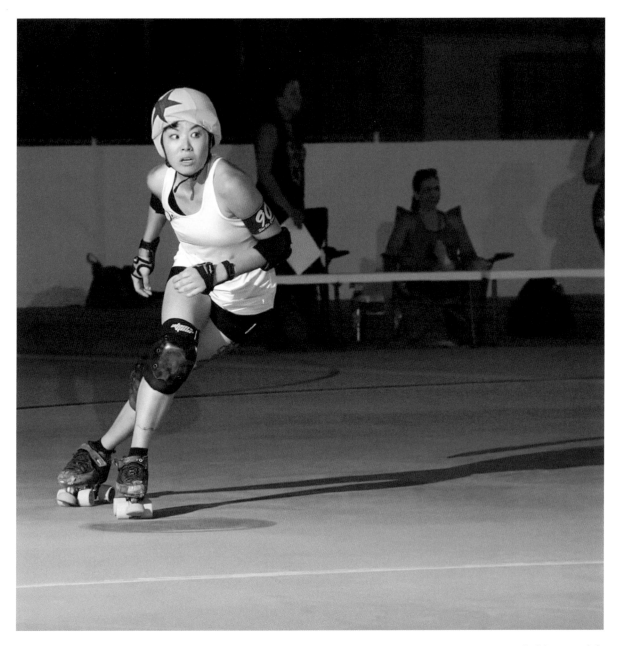

"**I TOOK A RISK WHEN** I became a Jammer in the roller derby. It's very difficult for women my age who are 40 and above. We are a solo challenger who has to charge through four blockers. We get hit a lot so physically it's harder than blocking. Most of my 7 year career was being a jammer and it fit perfectly with my personality because I'm competitive. You worry about injuries, but in the moment you totally forget about it and only think of winning. I broke my ankle without even knowing it for 7 weeks; it healed on its own. I also broke my wrist and had to have surgery. It was such a challenge, but I loved how I could use my competitive nature through this sport."

InYoung M.

Age 44 / Pet Groomer
Business Owner

LA MESA, NM
10 JAN 2020

"My parent(s) wanted me to live.

"**THE TRADITION I CARRY ON IS** the preservation of community and having the will to fight . . . I live at Everett Street, a six-unit building on the edge of Chinatown and Echo Park, a rapidly gentrifying area. We have faced 3 eviction notices from 2 new owners in the past six months . . . I am a Cambodian refugee that survived the walk to refugee camps in Thailand. I dodged bullets and land mines and endured beatings and starvation only to once again fight to live and fight to stay in my home."

Isabella M.

Chinatown Community for
Equitable Development

TEMPLE CITY, CA
14 AUG 2020

"I NEVER EXPECTED . . . I asked him to consider quarantining with me . . . It's been amazing getting to know this person in such a fast, intimate way." **CHRISTOPHER M. — KEY WEST, FL**

"FAMILY LOOKS LIKE . . . To deal with the boredom of quarantine, my family put our creativity into filming our own version of High School Musical . . ." **KAGEN Q. — SKOKIE, IL**

"FAMILY LOOKS LIKE . . . We all love . . . being together, playing these fun, kind of silly games. They really just help us bond and stay close as a family . . . and make the most out of it while we're here." **ALEX P. — CORNELIUS, NC**

"WHEN THIS IS OVER . . . Skateboarding with my son—that is something that, pre-Covid, would've never happened . . . The more time that goes by, the less angry I am about the quarantine." **VINCAS S. — NORTHVALE, NJ**

"I never expected to bury my oldest child. My son Max died at age 30 from a Fentanyl overdose.

I was devastated, but not shocked. Max battled his demons since he was a teenager—half of his life. I could go on about what those 15 years were like, but what I really want is purpose post-loss. I want to help someone else. My husband and I set out to rehab a sad, old house to be used for sober living. A safe place to live for people in active recovery. Max spent 9 months in recovery at BRC in Manor, TX. In October 2020, we donated a beautifully renovated four bedroom house to Fairview Recovery Services in Binghamton, NY, in Max's memory. It took 12 months, dozens of friends and volunteers, and generous local businesses and individuals to make The Maxwell House a reality. I've found new purpose."

Jennifer S.

Age 56 / Chief Operating Officer / AVRE

BINGHAMTON, NY
05 JAN 2021

"**I TOOK A RISK WHEN** I decided to start painting big. I was facing a Thyroid Cancer diagnosis and was afraid of the treatment (which included swallowing a radioactive pill and being in isolation). I painted big for the first time . . . and in the end never stopped. I've been painting for the last six years and it is my bliss and joy. Though I'd never wish an illness/diagnosis on anyone, I'm grateful that my path opened me to creativity and more joy."

Bronwen H.

Artist

HUNTINGDON VALLEY, PA
04 MAR 2020

263

"**MY GREATEST CHALLENGE IS** My Disabilities of Dyscalculia and Dyspraxia and My Autism because it makes being social quite a struggle because I have difficulty reading non-verbal body language and I can't take hints everything has to be spelled out for me, especially at work, I either make too much or too little eye contact, not because I'm trying to be rude I just don't know how much is enough, I also have difficulty keeping the connection going in most of My Friendships. My Dyspraxia makes it hard for me to move very fast and also it makes it harder to learn to drive a car. My Dyscalculia makes it so that I have difficulty doing even some of the most basic of math. Despite all this, I went to, lived at, and graduated from Schreiner University in Kerrville, Texas, with a Bachelor of Arts in General Studies."

Megan E. <
SAN ANTONIO, TX
30 JUL 2020

"**MY AMERICAN DREAM** is to live in a country where everyone has equal access to healthcare. As an American with Crohn's Disease, I am fortunate enough to have insurance that allows for my treatment. But I know this isn't the case with the majority of US residents, and everyone deserves an equal chance at life and recovery."

"**MY GREATEST CHALLENGE IS** reminding myself that I'm in charge of my own life . . . I suffered the consequences of a lot of the people who were supposed to be taking care of me."

Michelle C. ∧
PHOENIX, AZ
09 DEC 2019

Izzy W. >
LOS ANGELES, CA
14 JUL 2020

"I never expected to be where I am today.
I was fostered till I was 6. I was neglected,
starved, abused in every way possible.
At 6 I got adopted. My adopted dad sexually
abused me. I felt so alone and scared. By the
age of 15 I was always in trouble. I finally told
my mom what was happening. She didn't
believe me. But who could blame her I was
a troubled child. I was thrown back into
foster care. I felt so alone again. That feeling
left me empty. So I did drugs. I was homeless
and scared. Then I found the VOA homeless
youth center. I sobered up. Not right away
but I did.

I am now enrolled in college. Working on
my prerequisites for nursing school. I've
got all A's in my classes. I am going to
church and even have a wonderful boyfriend.
I am so grateful for what I've been through.
If I didn't go through that I wouldn't be
who I am today. Which is a responsible,
hardworking, sober adult."

A. C.
CLEARFIELD, UT
25 NOV 2020

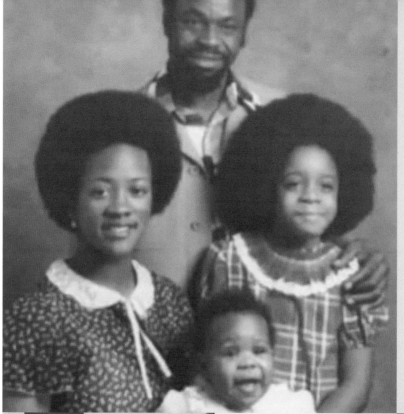

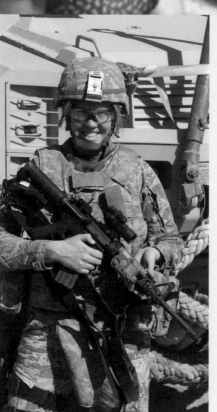

"MY GREATEST CHALLENGE IS learning how to be a working mom after being a stay-at-home mom for 12 years." JENNIFER S. — LAS CRUCES, NM

"MY AMERICAN STORY STARTED WHEN my mother, a high school graduate from Detroit, met my father, a Nigerian immigrant escaping the Biafran War in Detroit . . . I lived through some horrible situations growing up in Nigeria, but the only thing that kept me going was my hope of returning to America."

Oyinna O. ‹

HOUSTON, TX
22 SEP 2020

"I NEVER EXPECTED to be in a war zone . . . I didn't realize what I was signing up for the day I swore to serve and protect my country . . . I never expected to know what it felt like to hear the incoming sound of rockets and the fear that grips you when you know your life could end at any moment. I never expected most of what I experienced in that year I prepared for and deployed to Afghanistan. And though it was hard and came with deep scars, I am stronger than who I ever expected I could be."

Amanda H. ‹

CHANTILLY, VA
09 JAN 2021

"MY LIFE RIGHT NOW is celebrating purchasing my own home! From addiction, to homelessness, to recovery, to reunification, to HOMEOWNERSHIP!!"

Kelsey W. ‹

BILLINGS, MT
20 JAN 2021

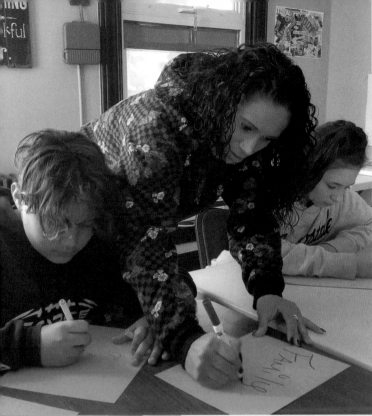

"MY GREATEST CHALLENGE IS being a single mother and a woman in recovery. I wake up every morning fighting for my life, but also being able to support my children and making sure they have food on the table. Working on my recovery from substance use is definitely hard, but I have to make sure I work on that. So I'm able to be a mother to my children. By the grace of God, he gives me the strength and wisdom to be able to wake up every day and fight."

Natacha D. ‹

NASHUA, NH
10 JAN 2020

"I NEVER EXPECTED to weigh 455 pounds but I did. When you fall into a deep depression you can gain weight pretty quickly . . . May of 2018 I decided to make a change for the better. My eating habits changed and I began to love myself more so my body started transforming and I loved it. I am currently at 358 pounds and still dropping weight . . . 103 pounds total dropped over 2 and 1/2 years is amazing and who did it????? I did."

Monica T. ‹

CLARKSVILLE, TN
20 JAN 2021

"A DAY'S WORK IS joyful, because I choose to make it so . . . My students see me struggle with what MS has done to my body . . . I hope that I can show them that they can choose joy too."

Robbin G. ⌃

EAST ORANGE, NJ
02 JAN 2020

"MY GREATEST CHALLENGE IS looking in the mirror and accepting myself as the person I am and who I am becoming." JESSICA W. — EASTON, PA

"My American story started when I became homeless. I realized that my body and my mind are my first home."

Paul J.

Age 36 / Farmer

ANTELOPE, CA
09 JUL 2020

"MY GREATEST CHALLENGE IS probably learning to accept this new person that I am after being married and having a kid. And it's really difficult because my body's changed and I've changed. My life has changed completely. And now I'm just learning to love my stretch marks and the different forms and shapes and jiggles that my body takes and now I realize that it's not necessarily that my body is ruined, but it's kind of like a stamp of how strong and powerful my body is and what it's capable of. And now I see strength in it rather than flaw."

Qarman W.

Stay at Home Mom

BURTONSVILLE, MD
10 JAN 2020

"MY GREATEST CHALLENGE IS learning that failure is a part of the journey. The world today can make you feel that when things go wrong, the feeling will never go away. I struggle with moving forward after failures, picking myself up and going on."

Katie B.

Age 19 / Student

RARITAN, NJ
09 MAR 2020

"MY GREATEST CHALLENGE IS to learn how to be alone."

William M.

Manager / Fire House Wines

RAPID CITY, SD
08 OCT 2019

"MY GREATEST CHALLENGE IS achieving academic and professional success as a dyslexic."

P. B.

Retired LMFT / Psychotherapist and CEO

ALBUQUERQUE, NM
03 JUN 2020

"MY GREATEST CHALLENGE IS fighting my agoraphobia daily. It got in my way so long ago but now I'm dealing with it so much better. It took a while but I no longer let it stop me from moving on."

Anonymous

NEW YORK, NY
24 AUG 2020

"I NEVER EXPECTED to have to raise three small children on my own. This was due to domestic violence from my children's father who I was with for 10 years. Although it has been very challenging, getting away from him was the best decision I made for my safety and my children's future."

A. L.

Age 30 / Graduate Student

FAYETTE CITY, PA
13 APR 2020

"MY GREATEST CHALLENGE IS self discipline."

Georgia C.

Age 42 / Barista, Military Veteran

LAS VEGAS, NV
20 NOV 2019

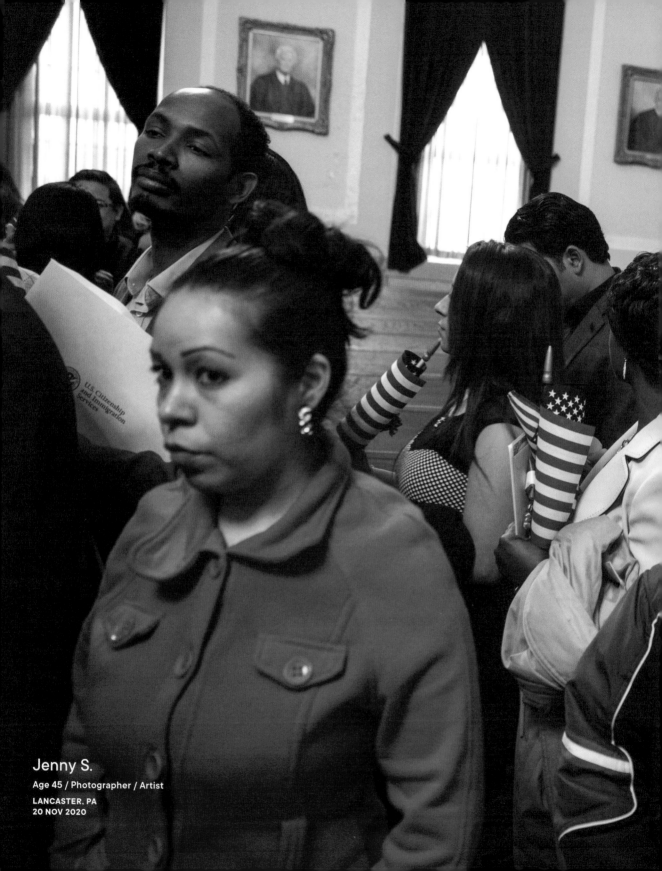

Jenny S.

Age 45 / Photographer / Artist

LANCASTER, PA
20 NOV 2020

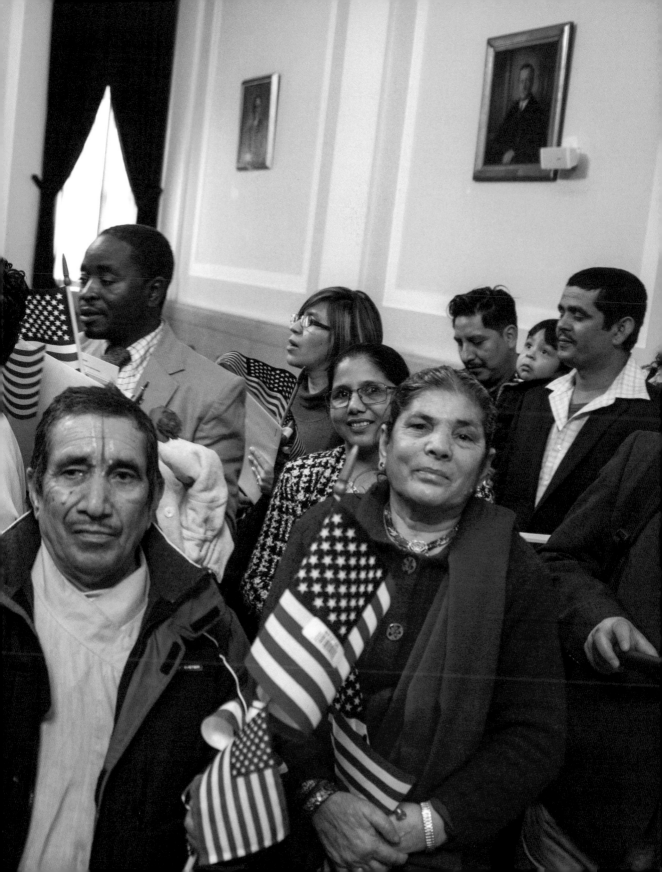

ACKNOWLEDGMENTS

American Portrait was made possible with the generous support of Target and the Anne Ray Foundation, as well as support from the Corporation for Public Broadcasting for the broadcast series.

SPECIAL THANKS

To all of the mothers and fathers and brothers and sisters and aunts and uncles and grandparents and friends and good neighbors and kind strangers and teachers and students and medics and patients and artists and writers and photographers and thinkers and chatterboxes and you . . . thank you, each and every one of you who shared your story.

To the teams at RadicalMedia, PBS, and HarperCollins and to the editors, designers, writers, researchers, coders, producers, art directors, animators, and other brilliant collaborators who brought this project together during the most challenging of times, working in empty office suites and tiny kitchen nooks, joining conference calls from the car, from home schooling breaks, at all hours and in all circumstances: we made this together.